Obsessed by Dress

Illustrated by Chesley McLaren

Obsessed by Dress

TOBI TOBIAS

Beacon Press Boston

Beacon Press
25 Beacon Street
Boston, Massachusetts 02108-2892
www.beacon.org

Beacon Press books are published under
the auspices of the Unitarian Universalist
Association of Congregations.
© 2000 by Tobi Tobias
All rights reserved
Printed in the United States of America
05 04 03 02 8 7 6 5 4 3 2
Credits appear on pages 172–176.
This book is printed on acid-free paper that meets
the uncoated paper ANSI/NISO specifications for
permanence as revised in 1992.
Book design by Julia Sedykh Design

Library of Congress Cataloging-in-Publication Data
Obsessed by dress / [compiled by] Tobi Tobias
p. cm.
ISBN 0-8070-0606-8 (cloth)
ISBN 0-8070-0607-6 (paper)
1. Clothing and dress—Quotations, maxims, etc. 2.
Costume—Quotations, maxims, etc. I. Tobias, Tobi.
PN6084.C535O27 2000
391—dc21

00-009021

Remembering my mother,

Esther Meshel Bernstein

1906–1999

contents

introduction 9

the argument 13

acquisition 14

the cost of clothes 19

clothes at the heart of the story 22

the body-dress connection 29

dress as self-expression 37

dress revealing, dress concealing 40

dressing for others . . . or ourselves? 42

the persuasive power of dress 44

fancy dress 47

fashion vs. mind and character 48

pleasure in dress 51

dress in words 52

accessories 57

lingerie 59

shoes 60

jewelry 65

cosmetics 68

mirrors 72

appearances 74

dressmaking 75

the mannequin 77

the tyranny of fashion 81

the mutability of fashion 83

secondhand clothes 87

fashion as history 90

fashion as art 92

color in dress 95

style 97

the street 99

indigenous dress 101

dressing for effect 102

parading dress 103

dishevelment 105

decorum 108

artifice 112

against ostentation 114

nudity 116

dandyism 120

feminism and dress 125

cross-dressing 130

the erotic power of dress 133

dress as depravity 139

the material world 140

what every woman knows 142

ball dress 145

mourning costume 148

uniforms 149

defying convention 154

nostalgia for clothes 159

age and dress 162

animals in clothes 165

fashion axioms 169

afterword 171

introduction

What a strange power there is in clothing. ISAAC
BASHEVIS SINGER · A part of this strangeness
of dress is that it links the biological body to the
social being, and public to private. ELIZABETH
WILSON · The beginning of all wisdom is to look
fixedly on clothes, or even with armed eyesight,
till they become *transparent.* THOMAS CARLYLE
· A person who sees only fashion in fashion is a
fool. HONORÉ DE BALZAC · Clothes are never
a frivolity: they always mean something, and that
something is to a large extent outside the control
of our conscious minds. JAMES LAVER · Dress has
never been at all a straightforward business: so
much subterranean interest and complex feeling
attaches to it. As a topic, it is popular because it
is dangerous—it has a flowery head but deep roots
in the passions. On the subject of dress almost no
one, for one or another reason, feels truly indif-
ferent: if their own clothes do not concern them,
somebody else's do. ELIZABETH BOWEN · Why,
then, would dress always be the most eloquent
means of expression, if it did not truly represent
the whole man—man in his political opinions, man
in the very essence of his existence, man rendered

in hieroglyphics? HONORÉ DE BALZAC · In my mind, I dress differently all the time. ANNA SUI · Dress is the frontier between the self and the not-self. ELIZABETH WILSON · In these rags they saw the possibility of becoming what they would have wished to be. RAYMOND RADIGUET

Clothing, clothes, apparel . . . raiment . . . garb, attire . . . fashion, style . . . vestment . . . garments, robes . . . finery . . . threads . . . menswear . . . womenswear . . . uniwear . . . wardrobe . . . outfit . . . wedding clothes . . . trousseau . . . ready-to-wear . . . rags, tatters, secondhand clothes . . . hand-me-downs . . . suit . . . uniform, livery . . . mufti . . . civvies . . . plain clothes . . . costume . . . masquerade, disguise . . . finery, frippery, fancy dress . . . Sunday best . . . glad rags . . . formal dress . . . evening dress, full dress . . . regalia, court dress . . . evening gown . . . cloak . . . outerwear, coat, jacket . . . overcoat . . . raincoat, slicker . . . waistcoat . . . vest . . . shirt . . . shift . . . blouse . . . sweater . . . dress, gown, frock . . . skirt . . . apron . . . pinafore . . . smock . . . pants, trousers . . . breeches . . . pantaloons, jeans, slacks . . . belt, sash . . . loincloth . . . G-string . . . diaper . . . dishabille . . . something more comfortable, negligee . . . casual clothes . . . night clothes . . . nightgown . . . pajamas . . . underwear, undies . . . unmention-

ables . . . lingerie . . . corset, stays . . . girdle . . .
garter belt . . . brassiere . . . headdress . . . millinery
. . . cap, hat . . . kerchief . . . veil . . . shoes, boots
. . . hosiery . . . stockings, socks . . . bathing suit,
trunks, bikini . . . layette . . . swaddling clothes.
ROGET'S INTERNATIONAL THESAURUS

Books on fashion will be sought and welcomed, at
all times and in every sphere, with special favour,
because they are both recreative and instructive, and
because everybody believes him or herself capable
of enjoying, of understanding, and of interpret-
ing them. LOUIS OCTAVE UZANNE · Someone
might say of me that I have only made a bouquet
of other people's flowers here, having supplied
nothing of my own but the thread to bind them.
MICHEL DE MONTAIGNE · By necessity, by pro-
clivity and by delight, we all quote. RALPH WALDO
EMERSON · When a thing has been said so well
that it could not be said better, why paraphrase it?
MARIANNE MOORE · I quote others only the better
to express myself. MICHEL DE MONTAIGNE

Now I'm trying to decide: Do I care more about
clothing or about literature? There isn't any great
difference. I respect clothing because it *is* litera-
ture. WAYNE KOESTENBAUM

the argument

One should either be a work of art, or wear
a work of art. —OSCAR WILDE
 1854–1900

Dress is at all times a frivolous distinction,
and excessive solicitude about it often destroys
its own aim. —JANE AUSTEN
 1775–1817

acquisition

Beware of all enterprises that require new clothes.
— HENRY DAVID THOREAU
1817–1862

There is no doubt a new dress is a help under all circumstances. — NOEL STREATFEILD
c. 1895–1986

Probably every new and eagerly expected garment ever put on since clothes came in, fell a trifle short of the wearer's expectation.
— CHARLES DICKENS
1812–1870

Marguerite [was given] a charming wax doll and a complete wardrobe of clothes and linens in a pretty chest of drawers. [She] was delighted with her lovely doll and her wardrobe. In the top drawer of the chest she found:

> *1 round straw hat with a little white feather*
> *and black velvet ribbons;*
> *1 blue taffeta bonnet with clusters of tiny roses;*
> *1 green parasol with an ivory handle;*

6 pairs of gloves;
4 pairs of lace-up boots;
2 silk scarfs;
1 muff and an ermine cape.

In the second drawer were:

6 chemises;
6 nightgowns;
6 pairs of pantalettes;
6 lace-trimmed petticoats with scalloped edging;
6 pairs of stockings;
6 handkerchiefs;
6 nightcaps;
6 collars;
6 pairs of sleeves;
2 corsets;
2 flannel petticoats;
6 towels;
6 sheets;
6 pillowcases;
6 tea towels;
a drawstring bag containing sponges, a large-toothed
 comb, a fine-toothed comb, a hairbrush, and
 a brush for cleaning the combs.

In the third drawer lay all the dresses and outer
garments. There were:

1 dress in Scotch merino;
1 dress in pink poplin;

1 dress in black taffeta;
1 dress in a blue fabric;
1 dress in white muslin;
1 dress in nankeen;
1 dress in black velvet;
1 dressing gown in lilac taffeta;
1 jacket in gray wool;
1 jacket in black velvet;
1 talma in black silk;
1 cloak in deep blue velvet;
1 cloak in embroidered white muslin.

Marguerite summoned Camille and Madeleine
to see all these beautiful things. That day and the
days that followed, they spent their time dressing
and undressing the doll, putting her to bed
[in her nightclothes], then waking her up again
[to change her costume for the many different
events in her day].　— SOPHIE ROSTOPCHINE
comtesse de Ségur
1799–1874

I love America, and I love American women.
But there is one thing that deeply shocks me —
American closets. I cannot believe one can dress
well when you have so much.

— ANDRÉE PUTMAN
b. 1925

Fashion is like the id. It makes you desire things
you shouldn't. — BOB MORRIS
b. 1958

When I see people dressed in hideous clothes
that look all wrong on them, I try to imagine the
moment when they were buying them and thought,
"This is great. I like it. I'll take it."

— ANDY WARHOL
c. 1928–1987

the cost of clothes

This morning came home my fine camlet cloak,
with gold buttons, and a silk suit, which cost me
much money, and I pray God to make me able
to pay for it. —SAMUEL PEPYS
1633–1703

Fond pride of dress is sure an empty curse;
E'er Fancy you consult, consult your purse.
—BENJAMIN FRANKLIN
1706–1790

In the matter of dress, one should always keep
below one's means.
—CHARLES-LOUIS DE SECONDAT
baron de La Brède et de Montesquieu
1689–1775

Here everyone dresses above his means.
—JUVENAL
55 to 60–c. 127

We sacrifice to dress, till household joys
And comforts cease. Dress drains our cellar dry,

And keeps our larder lean; puts out our fires,
And introduces hunger, frost, and woe,
Where peace and hospitality might reign.

<div align="right">— WILLIAM COWPER
1731–1800</div>

When I thought about my clothes I was too sad
to cry.

About clothes, it's awful. Everything makes
you want pretty clothes like hell. People laugh
at girls who are badly dressed. Jaw, jaw, jaw. . . .
"Beautifully dressed woman. . . ." As if it isn't
enough that you want to be beautiful, that you
want to have pretty clothes, that you want it like
hell. As if that isn't enough. But no, it's jaw, jaw
and sneer, sneer all the time. And the shop-
windows sneering and smiling in your face. And
then you look at the skirt of your costume, all
crumpled at the back. And your hideous under-
clothes. You look at your hideous underclothes
and you think "All right, I'll do anything for
good clothes. Anything—anything for clothes."

<div align="right">— JEAN RHYS
1894–1979</div>

"My dear, I had to laugh," she said. "D'you know
what a man said to me the other day? 'It's funny,'

he said, 'have you ever thought that a girl's clothes cost more than the girl inside them?'"

"What a swine of a man!" I said.

"Yes, that's what I told him," Maudie said. "'That isn't the way to talk,' I said. And he said, 'Well, it's true, isn't it? You can get a very nice girl for five pounds, a very nice girl indeed; you can even get a very nice girl for nothing if you know how to go about it. But you can't get a very nice costume for her for five pounds. To say nothing of underclothes, shoes, etcetera and so on.' And then I had to laugh, because after all it's true, isn't it? People are much cheaper than things."

— JEAN RHYS
1894–1979

Always be well dressed, even when begging.

— SAYING (Hindu)

clothes at the heart of the story

Do not look upon all this that I am telling you about the clothes as uncalled for or spun out, for they have a great deal to do with the story.

— MIGUEL DE CERVANTES SAAVEDRA
1547–1616

He took out a pile of shirts and began throwing them one by one before us, shirts of sheer linen and thick silk and fine flannel which lost their folds as they fell and covered the table in many-colored disarray. While we admired he brought more and the soft rich heap mounted higher — shirts with stripes and scrolls and plaids in coral and apple green and lavender and faint orange with monograms of Indian blue. Suddenly with a strained sound Daisy bent her head into the shirts and began to cry stormily.

"They're such beautiful shirts," she sobbed, her voice muffled in the thick folds. "It makes me sad because I've never seen such — such beautiful shirts before." — F. SCOTT FITZGERALD
1896–1940

I proceeded to the business center of Parkington and devoted the whole afternoon (the weather had cleared, the wet town was like silver-and-glass) to buying beautiful things for Lo. Goodness, what crazy purchases were prompted by the poignant predilection Humbert had in those days for check weaves, bright cottons, frills, puffed-out short sleeves, soft pleats, snug-fitting bodices and generously full skirts! Oh Lolita, you are my girl, as Vee was Poe's and Bea Dante's, and what little girl would not like to whirl in a circular skirt and scanties? Did I have something special in mind? coaxing voices asked me. Swimming suits? We have them in all shades. Dream pink, frosted aqua, glans mauve, tulip red, oolala black. What about playsuits? Slips? No slips. Lo and I loathed slips.

One of my guides in these matters was an anthropometric entry made by her mother on Lo's twelfth birthday (the reader remembers that Know-Your-Child book). I had the feeling that Charlotte, moved by obscure motives of envy and dislike, had added an inch here, a pound there; but since the nymphet had no doubt grown somewhat in the last seven months, I thought I could safely accept most of those January measurements: hip girth, twenty-nine inches; thigh girth (just below the gluteal sulcus), seventeen; calf girth and

neck circumference, eleven; chest circumference, twenty-seven; upper arm girth, eight; waist, twenty-three; stature, fifty-seven inches; weight, seventy-eight pounds; figure, linear; intelligence quotient, 121; vermiform appendix present, thank God.

Apart from measurements, I could of course visualize Lolita with hallucinational lucidity; and nursing as I did a tingle on my breastbone at the exact spot her silky top had come level once or twice with my heart; and feeling as I did her warm weight in my lap (so that, in a sense, I was always "with Lolita" as a woman is "with child"), I was not surprised to discover later that my computation had been more or less correct. Having moreover studied a midsummer sale book, it was with a very knowing air that I examined various pretty articles, sport shoes, sneakers, pumps of crushed kid for crushed kids. The painted girl in black who attended to all these poignant needs of mine turned parental scholarship and precise description into commercial euphemisms, such as *"petite."* Another, much older woman, in a white dress, with a pancake make-up, seemed to be oddly impressed by my knowledge of junior fashions; perhaps I had a midget for a mistress; so, when shown a skirt with two "cute" pockets in front, I intentionally put a naïve male question and was

rewarded by a smiling demonstration of the way the zipper worked in the back of the skirt. I had next great fun with all kinds of shorts and briefs— phantom little Lolitas dancing, falling, daisying all over the counter. We rounded up the deal with some prim cotton pajamas in popular butcher-boy style. Humbert, the popular butcher.

There is a touch of the mythological and the enchanted in those large stores where according to ads a career girl can get a complete desk-to-date wardrobe, and where little sister can dream of the day when her wool jersey will make the boys in the back row of the classroom drool. Lifesize plastic figures of snubbed-nosed children with dun-colored, greenish, brown-dotted, faunish faces floated around me. I realized I was the only shopper in that rather eerie place where I moved about fish-like, in a glaucous aquarium. I sensed strange thoughts form in the minds of the languid ladies that escorted me from counter to counter, from rock ledge to seaweed, and the belts and the bracelets I chose seemed to fall from siren hands into transparent water. I bought an elegant valise, had my purchases put into it, and repaired to the nearest hotel, well pleased with my day.

—VLADIMIR NABOKOV
1899–1977

The cloth of her dress clung to the velvet of his coat. She threw back her white neck which welled in a sigh, and, faltering, weeping, and hiding her face in her hands, with one long shudder, she abandoned herself to him.

<div align="right">

— GUSTAVE FLAUBERT
1821–1880

</div>

I knocked, and was told from within to enter. I entered, therefore, and found myself in a pretty large room, well lighted with wax candles. No glimpse of daylight was to be seen in it. It was a dressing-room, as I supposed from the furniture, though much of it was of forms and uses then quite unknown to me. But prominent in it was a draped table with a gilded looking-glass, and that I made out at first sight to be a fine lady's dressing-table.

Whether I should have made out this object so soon, if there had been no fine lady sitting at it, I cannot say. In an arm-chair, with an elbow resting on the table and her head leaning on that hand, sat the strangest lady I have ever seen, or shall ever see.

She was dressed in rich materials—satins, and lace, and silks—all of white. Her shoes were white. And she had a long white veil dependent from her hair, and she had bridal flowers in her hair, but her hair was white. Some bright jewels sparkled on

her neck and on her hands, and some other jewels lay sparkling on the table. Dresses, less splendid than the dress she wore, and half-packed trunks, were scattered about. She had not quite finished dressing, for she had but one shoe on—the other was on the table near her hand—her veil was but half arranged, her watch and chain were not put on, and some lace for her bosom lay with those trinkets, and with her handkerchief, and gloves, and some flowers, and a prayer-book, all confusedly heaped about the looking-glass.

It was not in the first moments that I saw all these things, though I saw more of them in the first moments than might be supposed. But, I saw that everything within my view which ought to be white, had been white long ago, and had lost its lustre, and was faded and yellow. I saw that the bride within the bridal dress had withered like the dress, and like the flowers, and had no brightness left but the brightness of her sunken eyes. I saw that the dress had been put upon the rounded figure of a young woman, and that the figure upon which it now hung loose, had shrunk to skin and bone. Once, I had been taken to see some ghastly wax-work at the Fair, representing I know not what impossible personage lying in state. Once, I had been taken to one of our old marsh

churches to see a skeleton in the ashes of a rich
dress, that had been dug out of a vault under the
church pavement. Now, wax-work and skeleton
seemed to have dark eyes that moved and looked
at me. I should have cried out, if I could.

<div align="right">

— CHARLES DICKENS
1812–1870

</div>

Dido herself with consecrated grain
In her pure hands, as she went near the altars,
Freed one foot from sandal straps, let fall
Her dress ungirdled, and, now sworn to death,
Called on the gods and stars that knew her fate.

<div align="right">

— VIRGIL
70–19 B.C.

</div>

And they clothed him with purple, and platted
a crown of thorns, and put it about his head,
 And began to salute him, Hail, King of the Jews!
 And they smote him on the head with a reed,
and did spit upon him, and bowing their knees
worshipped him,
 And when they had mocked him, they took off
the purple from him, and put his own clothes on
him, and led him out to crucify him.

<div align="right">

— MARK 15:17–20
King James Version (1611)

</div>

the body-dress connection

There is much to support the view that it is clothes
that wear us and not we them; we may make them
take the mould of arm or breast, but they would
mould our hearts, our brains, our tongues to
their liking. —VIRGINIA WOOLF
 1882–1941

No doubt Woman is sometimes a light, a glance,
an invitation to happiness, sometimes just a word;
but above all she is a general harmony, not only
in her bearing and the way in which she moves
and walks, but also in the muslins, the gauzes, the
vast, iridescent clouds of stuff in which she envelops
herself, and which are as it were the attributes
and the pedestal of her divinity; in the metal and
the mineral which twist and turn around her arms
and her neck, adding their sparks to the fire of
her glance, or gently whispering at her ears.
What poet, in sitting down to paint the pleasure
caused by the sight of a beautiful woman, would
venture to separate her from her costume? Where
is the man who, in the street, at the theatre, or
in the park, has not in the most disinterested of

ways enjoyed a skilfully composed toilette, and has not taken away with him a picture of it which is inseparable from the beauty of her to whom it belonged, making thus of the two things—the woman and her dress—an indivisible unity?

—CHARLES BAUDELAIRE
1821–1867

I naturally noticed—it was obvious—that I was unusually badly dressed, and even had an eye for others who were well dressed, but for years on end my mind did not succeed in recognizing in my clothes the cause of my miserable appearance. Since even at that time, I was on the way to underestimating myself, I was convinced that it was only on me that clothes assumed this appearance, first looking as stiff as a board, then hanging in wrinkles. . . . As a result I let the awful clothes affect even my posture, walked around with my back bowed, my shoulders drooping, my hands and arms at awkward angles. —FRANZ KAFKA
1883–1924

There are skilled dyers and weavers in Masahiro's household, and when it comes to dress, whether it be the color of his under-robe or the style of his cloak, he is more elegant than most men; yet the

only effect of his elegance is to make people say,
"What a shame someone else isn't wearing these
things!" — SEI SHŌNAGON
c. 966–c. 1013

Here we remembred how much Man is govern'd
by his senses, how lively he is struck by the objects
which appear to him in an agreeable manner, how
much clothes contribute to make us agreeable
objects, and how much we owe it to our selves that
we should appear so. — RICHARD STEELE
1672–1729

Whenas in silks my Julia goes,
Then, then (methinks) how sweetly flows
That liquefaction of her clothes.

Next, when I cast mine eyes and see
That brave vibration each way free;
O how that glittering taketh me!
— ROBERT HERRICK
1591–1674

Our clothes are too much a part of us for most of
us ever to be entirely indifferent to their condition:
it is as though the fabric were indeed a natural
extension of the body, or even of the soul.
— QUENTIN BELL
1910–1996

Dress has not only no social but also no signifi-
cant aesthetic existence unless it is actually
being worn. — ANNE HOLLANDER
 b. 1930

Clothes without a wearer, whether on a secondhand
stall, in a glass case, or merely a lover's garments
strewn on the floor, can affect us unpleasantly,
as if a snake had shed its skin. Similarly, a preg-
nant woman described how the little frock hanging
up in readiness for her as yet unborn child seemed
like "a ghost in reverse."
 — ELIZABETH WILSON
 b. 1936

There is something eerie about a museum of cos-
tume. . . . We experience a sense of the uncanny
when we gaze at garments that had an intimate
relationship with human beings long since gone
to their graves. For clothes are so much part of
our living, moving selves that, frozen on display
in the mausoleums of culture, they hint at some-
thing only half understood, sinister, threatening;
the atrophy of the body, and the evanescence
of life. — ELIZABETH WILSON
 b. 1936

Today our whole class went to the great costume store rooms of the theatre. . . . Each student [was to] prepare an external characterization and mask himself in it. . . . In examining carefully everything that was shown me, I hoped to happen on a costume which would suggest an appealing image to me.

My attention was drawn to a simple old morning coat. It was made of some remarkable material I had never seen before—a kind of sand-colored, greenish, grayish stuff, which seemed faded and covered with spots and dust mixed with ashes. I had the feeling that a man dressed in that coat would look like a ghost. An almost imperceptible squeamishness but at the same time a slightly terrifying sense of fatefulness stirred in me as I gazed at that old morning coat.

If one matched it with a hat, gloves, dusty foot gear, and prepared a make-up and wig in the same color and tones as the material—all grayish, yellowish, greenish, faded and shadowy, one would get a sinister, yet somehow familiar effect. Exactly what that effect was I could not yet determine.

The wardrobe attendants laid aside the coat I had chosen and promised to look for accessories to match—shoes, gloves, a high hat, as well as a

wig and beard. . . . Excited, disturbed, I left the costume rooms carrying away with me the riddle: what was the personality I should put on when I dressed myself in that decayed old morning coat?

From that moment on . . . something was going on inside of me: I was not I, in the sense of my usual consciousness of myself. Or to be more precise, I was not alone but with someone whom I sought in myself and could not find.

I existed, I went on with my usual life, yet something inhibited me from giving myself up to it fully; something was disturbing my usual existence. I seemed divided in two. . . . Half of my energy and human capability had somehow vanished and that loss sapped my strength and power and attention. . . . It was a fatiguing and tormenting state in which to be! It never left me for three whole days and in the course of that time the question of whom I was to play in the masquerade remained unanswered.

Finally in the night I suddenly woke up and everything was clear. That second life which I had been leading parallel to my usual one was a secret, subconscious life. In it there was going on the work of searching for that mildewed man whose clothes I had accidentally found.

— KONSTANTIN STANISLAVSKY
1863–1938

The dress must not hang on the body but follow its lines. It must accompany its wearer and when a woman smiles the dress must smile with her.

— MADELEINE VIONNET
1876–1975

dress as self-expression

Know, first, who you are; and then adorn yourself
accordingly. — EPICTETUS
<div align="right">

c. A.D. 55–c. 135
</div>

When it had been duly impressed upon her that
she was a young lady . . . she suddenly developed
a lively taste for dress. . . . Her judgment in this
matter was by no means infallible; it was liable
to confusions and embarrassments. Her great
indulgence of it was really the desire of a rather
inarticulate nature to manifest itself; she sought
to be eloquent in her garments, and to make up
for her diffidence of speech by a fine frankness
of costume. — HENRY JAMES
<div align="right">

1843–1916
</div>

1984: At a now-defunct boutique called Ben's
Village, I bought a pair of cotton tropical-print
unisex pants that I named "fish pants" because
blowsy fish swam on them in wallpaper patterns.

A friend had advised, when I'd told him there
was no room in my life for fish pants, "Change
your life to fit the pants."
<div align="right">

— WAYNE KOESTENBAUM
b. 1958
</div>

It must be someone
else wearing this new kimono
this New Year morning.

—BASHŌ
1644–1694

Fashion contains the potential for renewal and
transformation. The more costumes one has, the
more fantasy personas one can adopt.

—EDITH GOULD
b. 1941

It does not seem fair that, unbeknown to you,
every single item you put on your body literally
shouts out your unconscious dreams and desires
to the entire world. Everyone who sees you can
read you like a book, yet you yourself have no idea
what you're saying. —CYNTHIA HEIMEL
b. 1947

Clothes are . . . nothing less than the furniture
of the mind made visible. —JAMES LAVER
1899–1975

Being "well dressed" is not a question of having
expensive clothes or the "right" clothes—I don't
care if you're wearing rags—but they must suit you.

—LOUISE NEVELSON
c. 1900–1988

Why not be one's self? That is the whole secret of a successful appearance. If one is a greyhound, why try to look like a Pekingese?

— EDITH SITWELL
1887–1964

I should like my dress to be a poem about myself, my *persona,* the outward and visible presentation of my individuality. And that particular mode and fabric and manner which I should choose might not at all recommend itself to my next-door neighbour. Indeed, I hope it would not. For the loveliest and most human thing about humanity is the infinity of its types and modes of manifestation.

— "A GIRL GRADUATE"
Pall Mall Gazette (1884)

dress revealing, dress concealing

Once, early in the morning,
Beelzebub arose,
With care his sweet person adorning,
He put on his Sunday clothes.

— PERCY BYSSHE SHELLEY
1792–1822

Clothes can suggest, persuade, connote, insinuate,
or indeed lie, and apply subtle pressure while their
wearer is speaking frankly and straightforwardly
of other matters. — ANNE HOLLANDER
b. 1930

O what a sight were Man, if his attires
Did alter with his minde;
And like a dolphins skinne, his clothes combin'd
With his desires!

— GEORGE HERBERT
1593–1633

He [the Courtier] ought to consider what appear-
ance he wishes to have and what manner of man
he wishes to be taken for, and dress accordingly;

and see to it that his attire aid him to be so regarded even by those who do not hear him speak or see him do anything whatever.

— BALDASSARE CASTIGLIONE
1478–1529

You wouldn't know me to see me dressed!

— JAMES WHITCOMB RILEY
1849–1916

dressing for others . . . or ourselves?

The Cranford ladies' . . . dress is very independent of fashion; as they observe, "What does it signify how we dress here at Cranford, where everybody knows us?" And if they go from home, their reason is equally cogent, "What does it signify how we dress here, where nobody knows us?"

— ELIZABETH GASKELL
1810–1865

Neglect of apparel, even among the most intimate friends, does insensibly lessen their regards to each other. — JOHN HUGHES
1677–1720

Think of dress in every light
　'Tis woman's chiefest duty;
Neglecting that, ourselves we slight
　And undervalue beauty.
That allures the lover's eye,
　And graces every action;
Besides, when not a creature's by,
　'Tis inward satisfaction.

— JOHN GAY
1685–1732

To wash one's hair, make one's toilet, and put on
scented robes; even if not a soul sees one, these
preparations still produce an inner pleasure.

— SEI SHŌNAGON
c. 966–c. 1013

A good many women who buy new clothes are
afflicted by the delusion that they will thereby
change their state of mind, the attitude of their
companions, and their lives.

— KENNEDY FRASER
b. 1946

It would be mortifying to the feelings of many
ladies could they be made to understand how little
the heart of man is affected by what is costly or new
in their attire. . . . Woman is fine for her satis-
faction alone. — JANE AUSTEN
1775–1817

There's not a woman alive who can spare a thought
for her lover when she's absorbed in making her
toilette.

— MARIE-MADELEINE PIOCHE DE LA VERGNE
comtesse de La Fayette
1634–1693

the persuasive power of dress

Good clothes open all doors.

— THOMAS FULLER
1654–1734

She had a womanly instinct that clothes possess
an influence more powerful over many than
the worth of character or the magic of manners.

— LOUISA MAY ALCOTT
1832–1888

A man must be a profound calculator to be a con-
summate dresser. One must not dress the same,
whether one goes to a minister or a mistress; an
avaricious uncle, or an ostentatious cousin: there
is no diplomacy more subtle than that of dress.

— EDWARD GEORGE EARLE BULWER-LYTTON
first baron Lytton
1803–1873

Clothing should be used as a tool and as a weapon.

— JOHN T. MOLLOY
b. 1937

A policeman in plain clothes is one man; in his uniform he is ten. Clothes and title are the most potent thing, the most formidable influence, in the earth. They move the human race to willing and spontaneous respect for the judge, the general, the admiral, the bishop, the ambassador, the frivolous earl, the idiot duke, the sultan, the king, the emperor. No great title is efficient without clothes to support it. — MARK TWAIN
1835–1910

What would a man be—what would *any* man be— without his clothes? As soon as one stops and thinks over that proposition, one realizes that without his clothes a man would be nothing at all; that the clothes do not merely make the man, the clothes *are* the man; that without them he is a cipher, a vacancy, a nobody, a nothing. — MARK TWAIN
1835–1910

I have to dress pretty well in my business.
— WILLA CATHER
1873–1947

A detailed examination of what passes in popular apprehension for elegant apparel will show that it is contrived at every point to convey the impression

that the wearer does not habitually put forth any useful effort. — THORSTEIN VEBLEN
1857–1929

If velvet and silk hang in your closet, you can step out in rags. — SAYING (Jewish)

Children should be allowed to dress like their friends. Nothing makes a child, especially a boy, more self-conscious than to look "strange" to the children he plays with. In other words the mother who dresses a boy—or even a girl—in noticeably different clothes, may make the child not merely temporarily unhappy but can very easily set him so far apart, as to warp his whole future life.
— EMILY POST
1872–1960

Only God helps the badly dressed.
— SAYING (Spanish)

Clothes make the man. Naked people have little or no influence in society. — MARK TWAIN
1835–1910

fancy dress

Clothes make a statement. Costumes tell a story.

— MASON COOLEY
b. 1927

The witty woman . . . chooses for her carnival costume one which ingeniously reveals something in her spirit or heart which the conventions of her everyday life conceal; and when she puts on the hideous long-nosed Venetian mask, she tells us, not only that she has a classic nose behind it, but that she has much more, and may well be adored for things other than her mere beauty. So speaketh the Arbiter of the masquerade: "By thy mask I shall know thee."

— ISAK DINESEN
1885–1962

No mask like open truth to cover lies,
As to go naked is the best disguise.

— WILLIAM CONGREVE
1670–1729

All dress is fancy dress, is it not, except our natural skins? — GEORGE BERNARD SHAW
1856–1950

fashion vs. mind and character

You cannot be both fashionable and first-rate.
— LOGAN PEARSALL SMITH
1865–1946

I love to be well dress'd Sir: and think it
No scandal to my understanding.
— GEORGE ETHEREGE
c. 1635–c. 1692

Any affectation whatsoever in dress implies, in my
mind, a flaw in the understanding.
—PHILIP DORMER STANHOPE
fourth earl of Chesterfield
1694–1773

In species after species, the females are sensible in
their size, attire and accessories, while the males
are often oversize, overdressed and burdened with
awkward appendages and seemingly foolish
patterns of behavior. — CHARLES DARWIN
1809–1882

Singularity in dress is ridiculous; in fact, it is

generally looked upon as a proof that the mind is somewhat deranged.

— SAINT JEAN-BAPTISTE DE LA SALLE
1651–1719

Poets, artists, and men of genius in general are seldom coxcombs, but often slovens; for they find something out of themselves better worth studying than their own persons.

— WILLIAM HAZLITT
1778–1830

Fine clothes are good only as they supply the want of other means of procuring respect.

— SAMUEL JOHNSON
1709–1784

"Whatever comes," she said, "cannot alter one thing. If I am a princess in rags and tatters, I can be a princess inside. It would be easy to be a princess if I were dressed in cloth of gold, but it is a great deal more of a triumph to be one all the time when no one knows it."

— FRANCES HODGSON BURNETT
1849–1924

It's always the badly dressed people who are the most interesting. — JEAN PAUL GAULTIER
b. 1952

When I free my body from its clothes, from all their buttons, belts, and laces, it seems to me that my soul takes a deeper, freer breath.

— AUGUST STRINDBERG
1849–1912

Thy clothes are all the soul thou hast.

— FRANCIS BEAUMONT
c. 1585–1616
JOHN FLETCHER
1579–1625

Fashion is just a name for one of the things that happen where mind and body intersect. Fashion is more than an outfit that . . . disappears after one season. It is also worth examining as the physical intelligence some women project when draped.

— HERBERT MUSCHAMP
b. 1947

A man cannot dress, but his ideas get cloath'd at the same time.

— LAURENCE STERNE
1713–1768

It is only when the mind and character slumber that the dress can be seen.

—RALPH WALDO EMERSON
1803–1882

pleasure in dress

I have heard with admiring submission the expe-
rience of the lady who declared that the sense of
being perfectly well dressed gives a feeling of inward
tranquility which religion is powerless to bestow.
— RALPH WALDO EMERSON
1803–1882

Any man may be in good spirits and good temper
when he's well dressed. There an't much credit in
that. — CHARLES DICKENS
1812–1870

They may talk of a comet, or a burning mountain,
or some such bagatelle; but to me a modest woman,
dressed out in all her finery, is the most tremen-
dous object of the whole creation.
— OLIVER GOLDSMITH
1730–1774

Like every good man, I strive for perfection, and,
like every ordinary man, I have found that perfec-
tion is out of reach—but not the perfect suit.
— EDWARD TIVNAN
b. 1945

dress in words

He was worth looking at. He wore a shaggy bor-
salino hat, a rough gray sports coat with white golf
balls on it for buttons, a brown shirt, a yellow
tie, pleated gray flannel slacks and alligator shoes
with white explosions on the toes. From his outer
breast pocket cascaded a show handkerchief of
the same brilliant yellow as his tie. There were a
couple of colored feathers tucked into the band
of his hat, but he didn't really need them. Even on
Central Avenue, not the quietest dressed street
in the world, he looked about as inconspicuous as
a tarantula on a slice of angel food.

— RAYMOND CHANDLER

1888–1959

Their trains and jackets were, of course, embroi-
dered. The jackets had decorated cuffs; silver thread
stitched down the seams of the trains had been
made to look like braid; and silver foil was inlaid
into the figured pattern on the fans. It was like
looking at snow-clad mountains by the light of a
clear moon. The brightness was such, indeed, that

you could hardly recognize anything, as if the
room were hung with mirrors.

<div align="right">

— MURASAKI SHIKIBU
c. 978 – c. 1014

</div>

If . . . I found the Duchess swathed in the mist of
a grey crêpe de Chine gown, I accepted this aspect
of her which I felt to be due to complex causes
and to be quite unalterable, and steeped myself in
the atmosphere which it exhaled, like that of cer-
tain late afternoons cushioned in pearly grey by
a vaporous fog; if, on the other hand, her indoor
gown was Chinese with red and yellow flames,
I gazed at it as at a glowing sunset; these garments
were not a casual decoration alterable at will, but
a given, poetical reality like that of the weather,
or the light peculiar to a certain hour of the day.

<div align="right">

— MARCEL PROUST
1871–1922

</div>

 . . . I'm
Weaving a dress for my lady
Out of the fabric of dreams;
Fashioned of twilight,
Sewn with the shy light
Of stars and the moon's fragile beams;
Clasped with a girdle of dawning,

Rainbows to cover the seams,
Brightened with kisses,
Ladylove, this is
Your gown from my fabric of dreams!

<div align="right">

— B. G. DE SYLVA
1895–1950
ARTHUR FRANCIS [IRA GERSHWIN]
1896–1983

</div>

The door of the jail being flung open from within
. . . a young woman . . . stepped into the open
air, as if by her own free-will. She bore in her
arms a child, a baby of some three months old, who
winked and turned aside its little face from the
too vivid light of day; because its existence, hereto-
fore, had brought it acquainted only with the
gray twilight . . . of the prison.

When the young woman—the mother of this
child—stood fully revealed before the crowd, it
seemed to be her first impulse to clasp the infant
closely to her bosom; not so much by an impulse
of motherly affection, as that she might thereby
conceal a certain token, which was wrought or
fastened into her dress. In a moment, however,
wisely judging that one token of her shame would
but poorly serve to hide another, she took the
baby on her arm, and, with a burning blush, and

yet a haughty smile, and a glance that would not
be abashed, looked around at her townspeople and
neighbours. On the breast of her gown, in fine
red cloth, surrounded with an elaborate embroi-
dery and fantastic flourishes of gold thread,
appeared the letter A. It was so artistically done,
and with so much fertility and gorgeous luxuri-
ance of fancy, that it had all the effect of a last and
fitting decoration to the apparel which she wore;
and which was of a splendor in accordance with
the taste of the age, but greatly beyond what was
allowed by the sumptuary regulations of the colony.

The young woman was tall, with a figure of
perfect elegance, on a large scale. She had dark
and abundant hair, so glossy that it threw off the
sunshine with a gleam, and a face which, besides
being beautiful from regularity of feature and
richness of complexion, had the impressiveness
belonging to a marked brow and deep black eyes.
She was lady-like, too, after the manner of the
feminine gentility of those days; characterized by
a certain state and dignity. . . . Those who had
before known her, and had expected to behold
her dimmed and obscured by a disastrous cloud,
were astonished, and even startled, to perceive
how her beauty shone out, and made a halo of
the misfortune and ignominy in which she was

enveloped. . . . Her attire, which, indeed, she had wrought for the occasion, in prison, and had modelled much after her own fancy, seemed to express the attitude of her spirit, the desperate recklessness of her mood, by its wild and pictur-esque peculiarity. But the point which drew all eyes, and, as it were, transfigured the wearer — so that both men and women who had been familiarly acquainted with Hester Prynne, were now impressed as if they beheld her for the first time — was that SCARLET LETTER, so fantastically embroidered and illuminated upon her bosom. It had the effect of a spell, taking her out of the ordinary relations with humanity, and inclosing her in a sphere by herself. — NATHANIEL HAWTHORNE
1804–1864

accessories

He [Lucien de Rubempré, a provincial poet on his first visit to Paris] watched the passers-by, graceful, smart, elegant young men of the Faubourg Saint-Germain: all of them having a special *cachet*. . . . He saw around him exquisite studs on gleaming white shirts: his were russet-brown! All these elegant gentlemen had beautifully cut gloves while his were fit only for a policeman! One of them toyed with a handsome bejewelled cane, another's shirt had dainty gold cuff-links at the wrists. Another of them, as he chatted with a lady, twirled a charming riding-whip, and the ample folds of his slightly mud-spattered trousers, his clinking spurs and his small, tight-fitting riding-coat showed that he was about to mount one of the two horses held in check by a diminutive groom. And another was drawing from his waistcoat pocket a watch as flat as a five-franc piece and was keeping his eye on the time like a man who was too early or too late for a rendezvous. At the sight of these fascinating trifles which were something new to Lucien, he became aware of a world in which the superfluous is indispensable. — HONORÉ DE BALZAC
1799–1850

Stars in the purple dusk above the rooftops
Pale in a saffron mist and seem to die,
And I myself on a swiftly tilting planet
Stand before a glass and tie my tie.

<div align="right">

— CONRAD AIKEN
1889–1973

</div>

lingerie

Brevity is the soul of lingerie. — DOROTHY PARKER
1893–1967

Having hooked up O's bodice in front, [she] began
to lace it up tight in the back. The bodice was long
and stiff, stoutly whale-boned as during the period
when wasp waists were in style, with gussets to sup-
port the breasts. The more the bodice was tightened,
the more the breasts were lifted, supported as they
were by the gussets, and the nipples displayed more
prominently. At the same time, the constriction of
the waist caused her stomach to protrude and her
backside to arch out sharply. The strange thing was
that this armor was very comfortable and to a certain
extent restful. It made you stand up very straight,
but it made you realize—why, it was hard to tell unless
it was by contrast—the freedom, or rather the avail-
ability, of that part of the body left unrestricted.

— PAULINE RÉAGE
1907–1998

From the cradle to the coffin underwear comes first.

— BERTOLT BRECHT
1898–1956

shoes

The loveliest red shoes. . . . To Karen nothing
else in the world was so desirable. . . . [But] it
was not proper to wear red shoes when you were
being confirmed. . . .

Everyone in the church looked at Karen's
feet, as she walked toward the altar. On the walls
of the church hung paintings of the former
ministers and their wives who were buried there;
they were portrayed wearing black with white
ruffs around their necks. Karen felt that even
they were staring at her red shoes.

When the old bishop laid his hands on her
head and spoke of the solemn promise she was
about to make—of her covenant with God to
be a good Christian—her mind was not on his
words. . . . When she knelt in front of the altar
and the golden cup was lifted to her lips, she
thought only of the red shoes and saw them
reflected in the wine.

—HANS CHRISTIAN ANDERSEN
1805–1875

Bringing the slipper to her dainty foot, he saw
that she had no trouble getting into it, that
the slipper fit her foot as perfectly as a wax coat-
ing. The amazement . . . was great, but greater
still when [she] drew from her pocket the mate to
the little slipper and put it on. At that point, the
fairy godmother arrived, who, having touched her
wand to Cinderella's clothes, made them even
more magnificent than before.

— CHARLES PERRAULT
1628–1703

The child's foot is not yet aware it's a foot,
and would like to be a butterfly or an apple.

But in time, stones and bits of glass,
streets, ladders,
and the paths in the rough earth
go on teaching the foot that it cannot fly,
cannot be a fruit bulging on the branch.
Then, the child's foot
is defeated, falls
in the battle,
is a prisoner
condemned to live in a shoe.

— PABLO NERUDA
1904–1974

Shoes are the first adult machines we are given to
master. — NICHOLSON BAKER
b. 1957

In his new boots, Joe Buck was six-foot-one and
life was different. As he walked out of that store in
Houston something snapped in the whole bottom
half of him: A kind of power he never even knew
was there had been released in his pelvis and he was
able to feel the world through it. Brand-new mus-
cles came into play in his buttocks and in his legs,
and he was aware of a totally new attitude toward
the sidewalk. The world was down there, and he
was way up here, on top of it, and the space between
him and it was now commanded by a beautiful
strange animal, himself, Joe Buck. He was strong.
He was exultant. He was ready.
— JAMES LEO HERLIHY
1927–1993

I don't know who invented the high heel, but all
men owe him a lot. — MARILYN MONROE
1926–1962

There was once upon a time a king who had twelve
daughters, each one more beautiful than the
other. They all slept together in one chamber, in

which their beds stood side by side, and every
night when they were in them the king locked the
door, and bolted it. But in the morning when
he unlocked the door, he saw that their shoes were
worn out with dancing, and no one could find
out how that had come to pass.

—JAKOB GRIMM
1785–1863
WILHELM GRIMM
1786–1859

Please send me your last pair of shoes, worn out
with dancing, as you mentioned in your letter, so
that I might have something to press against my
heart. —JOHANN WOLFGANG VON GOETHE
1749–1832

I belong to a family in which everyone has sound,
solid shoes. My mother even had to have a little
wardrobe made especially to hold her shoes, she
had so many pairs. When I go home to visit, they
utter cries of indignation and sorrow at the sight of
my shoes. But I know that even with worn-out
shoes, one can still live. — NATALIA GINZBURG
1906–1991

"The Silver Shoes," said the Good Witch, "have wonderful powers. And one of the most curious things about them is that they can carry you to any place in the world in three steps, and each step will be made in the wink of an eye. All you have to do is to knock the heels together three times and command the shoes to carry you wherever you wish to go."

"If that is so," said the child joyfully, "I will ask them to carry me back to Kansas at once."

— L. FRANK BAUM
1856–1919

jewelry

"How very beautiful these gems are!" said
Dorothea. . . . "It is strange how deeply colours
seem to penetrate one, like scent. I suppose that is
the reason why gems are used as spiritual emblems
in the Revelation of St. John. They look like
fragments of heaven." — GEORGE ELIOT
1819–1880

Freyja found the . . . path [that] became a passage
between rock and rock and she followed it until
it led into a large dank cavern. There the goddess
stood motionless. . . . She heard the sound of
distant tapping, and her own heart began to beat
faster, to hammer with longing.

The goddess sidled through the dismal cave.
The sound of the tapping, insistent yet fitful, grew
stronger and stronger. Freyja . . . eased her way
down a narrow groin, and stepped into the swel-
tering smithy of the four dwarfs, Alfrigg and Dvalin,
Berling and Grerr.

For a moment Freyja was dazzled by the brilliance
of the furnace. She rubbed her eyes, and then she

gasped as she saw the breathtaking work of the dwarfs—a necklace, a choker of gold incised with wondrous patterns, a marvel of fluid metal twisting and weaving and writhing. She had never seen anything so beautiful nor so desired anything before.

The four dwarfs, meanwhile, stared at the goddess—she shimmered in the warm light of the forge. They had never seen anyone so beautiful nor so desired anyone before.

Freyja smiled at Alfrigg and Dvalin and Berling and Grerr. "I will buy that necklace from you," she said.

The four dwarfs looked at each other. Three shook their heads and the fourth said, "It's not for sale."

"I want it," said Freyja. "I'll pay you with silver and gold—a fair price and more than a fair price." . . .

"We have enough silver," said one dwarf.

"And we have enough gold," said another.

Freyja gazed at the necklace. She felt a great longing for it, a painful hunger. . . .

"What is your price?" asked the goddess.

"It belongs to us all," said one dwarf.

"So what each has must be had by the others," said the second, leering.

"There's only one price," said the third, "that will satisfy us."

The fourth dwarf looked at Freyja. "You," he said.

"Only if you will lie one night with each of us will this necklace ever lie round your throat," said the dwarfs.

Freyja's distaste for the dwarfs—their ugly faces, their pale noses, their misshapen bodies and their small greedy eyes—was great, but her desire for the necklace was greater. Four nights were but four nights; the glorious necklace would adorn her for all time.

"As you wish," murmured Freyja shamelessly. "As you wish. I am in your hands."

Four days passed; four nights passed. Freyja kept her part of the bargain. Then the dwarfs, too, kept their word. They presented the necklace to Freyja and fastened it round her throat. The goddess hurried out of the cavern . . . and her shadow followed her. . . . Under her cloak, she wore the necklace of the Brisings.

— KEVIN CROSSLEY-HOLLAND
b. 1941
after early Icelandic sources

cosmetics

There is a mysterious stillness and intimacy of a woman doing her hair and making up which attracts me. — PEDRO ALMODÓVAR
b. c. 1949

[The] mystery of a sensation, of a voluptuousness far more profound, undefinable, of painting something that goes on living underneath . . .
— JACQUES-HENRI LARTIGUE
1894–1986

No elegance is possible without perfume.
— GABRIELLE ("COCO") CHANEL
1883–1971

What else do they want in life but to be as attractive as possible to men? Do not all their trimmings and cosmetics have this end in view, and all their baths, fittings, creams, scents, as well—and all those arts of making up, painting, and fashioning the face, eyes, and skin?

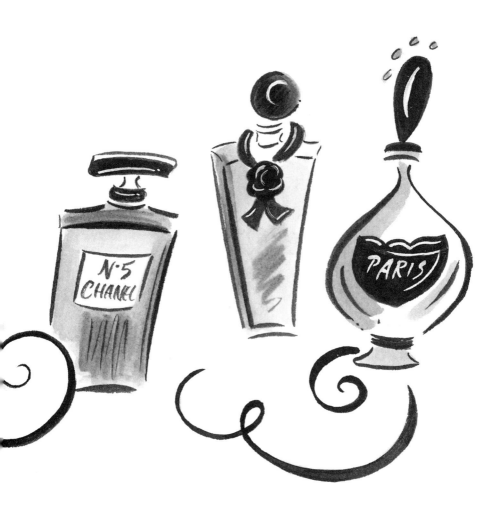

Just so. And by what other sponsor are they better
recommended to men than by folly?

— DESIDERIUS ERASMUS
1469–1536

Before she allows the world to judge her face,
a woman is entitled to create it.

— KENNEDY FRASER
b. 1946

Eleanor Rigby . . .

.

Waits at the window, wearing the face that she
keeps in a jar by the door.

— JOHN LENNON
1940–1980
PAUL MCCARTNEY
b. 1942

In the factory, we make cosmetics; in the store we
sell hope. — CHARLES REVSON
1906–1975

A girl whose cheeks are covered with paint
Has an advantage with me over one whose ain't.

— OGDEN NASH
1902–1971

Against Him those women sin who torment their
skin with potions, stain their cheeks with rouge
and extend the line of their eyes with black color-
ing. Doubtless they are dissatisfied with God's
plastic skill. In their own persons they convict and
censure the Artificer of all things.

— TERTULLIAN
155 to 160—after 220

If I make the lashes dark
And the eyes more bright
And the lips more scarlet,
Or ask if all be right
From mirror after mirror,
No vanity's displayed:
I'm looking for the face I had
Before the world was made.

— W. B. YEATS
1865–1939

mirrors

One must look at oneself carefully, the younger
sister went on. How else can one manage to array
oneself properly? Do you think a girl is like a flower,
able to arrange her leaves about her without using
a mirror? —JEAN DE LA FONTAINE
 1621–1695

When a woman comes to her glass, she does not
employ her time in making herself look more
advantageously what she really is, but endeavours
to be as much another creature as she possibly can.
Whether this happens because they stay so long
and attend their work so diligently that they forget
the faces and persons which they first sat down
with, or whatever it is, they seldom rise from the
toilet the same women they appeared when they
began to dress. —JOSEPH ADDISON
 1672–1719

It is eleven years since I have seen my figure in a
glass. The last reflection I saw there was so disagree-

able, I resolved to spare myself such mortifications
for the future.

<div align="right">

— LADY MARY WORTLEY MONTAGU
1689–1762

</div>

Mirrors should think longer before they reflect.

<div align="right">

— JEAN COCTEAU
1889–1963

</div>

Let us be grateful to the mirror for revealing to us
our appearance only. — SAMUEL BUTLER

<div align="right">

1835–1902

</div>

appearances

Three-tenths of a good appearance are due to
nature; seven-tenths to dress. — S A Y I N G (Chinese)

A stick dressed up doesn't look like a stick.
— S A Y I N G (Spanish)

Judge not according to the appearance.
— J O H N 7:24
King James Version (1611)

Appearances are not held to be a clue to the truth.
But we seem to have no other.
— I V Y C O M P T O N - B U R N E T T
1884–1969

It is only shallow people who do not judge by
appearances. The true mystery of the world is the
visible, not the invisible. — O S C A R W I L D E
1854–1900

Things are entirely what they appear to be and
behind them . . . there is nothing.
— J E A N - P A U L S A R T R E
1905–1980

dressmaking

Meanwhile, in the dining room the scene was
being set for the evening. Polda and Pauline, the
seamstresses, spread themselves out there with the
props of their trade. Carried on their shoulders,
a silent immobile lady had entered the room,
a lady of oakum and canvas, with a black wooden
knob instead of a head. But when stood in the
corner, between the door and the stove, that
silent woman became mistress of the situation.
Standing motionless in her corner, she super-
vised the girls' advances and wooings as they knelt
before her, fitting fragments of a dress marked
with white basting thread. They waited with
attention and patience on the silent idol, which
was difficult to please. That moloch was inexorable
as only a female moloch can be, and sent them
back to work again and again, and they, thin and
spindly, like wooden spools from which thread
is unwound and as mobile, manipulated with deft
fingers the piles of silk and wool, cut with noisy
scissors into its colorful mass, whirred the sewing
machine, treading its pedal with one cheap

patent-leathered foot, while around them there grew a heap of cuttings, of motley rags and pieces, like husks and chaff spat out by two fussy and prodigal parrots. The curved jaws of the scissors tapped open like the beaks of those exotic birds.

The girls trod absent-mindedly on the bright shreds of material, wading carelessly in the rubbish of a possible carnival, in the storeroom for some great unrealized masquerade. They disentangled themselves with nervous giggles from the trimmings, their eyes laughed into the mirrors. Their hearts, the quick magic of their fingers, were not in the boring dresses which remained on the table, but in the thousand scraps, the frivolous and fickle trimmings, with the colorful fantastic snowstorm with which they could smother the whole city. — BRUNO SCHULZ
1892–1942

the mannequin

Men, nowadays, feel . . . at home wherever femi-
nine luxury is created and displayed. Freely and
frankly they admit their liking for these sartorial
rites that every famous couturier organizes with
theatrical and religious pomp. Monsieur accom-
panies Madame to the dress shows and Madame
nods knowingly; "Yes, of course, to have a good
look at the mannequins." In which she is frequently
wrong. . . .

While his secretly frenzied female companion
is having her heart torn to shreds as she renounces
a little "creation" at six thousand francs, the bliss-
fully relaxed male is drinking in knowledge. He
notes the low waist at X, the drapery at Z, as he
might memorize the characteristics of a school of
painting. Man appreciates a total effect far better
than woman does. He likewise—and in all inno-
cence—realizes better than she how much is due to
the mannequin. While a fevered female spectator
keeps muttering under her breath, "That's the one,
that's it, that's the dress I want," the judicious
male is admiring not only a bronze sheath more
revealing than a swim-suit but the milky whiteness

and the copper hair of the redhead who is wearing it. He knows that the tunic, the colour of absinthe and moonlight, would lose everything if it were sundered from that girl who has the dignity of a greyhound and whose long hair has never been outraged by scissors or curling tongs. He realizes, at last, that a serious mission has devolved on what his wife, between clenched teeth, calls "that creature." Is it criminal of him, if he wants the dress, to long at times to carry it off as the design-er conceived it . . . in other words on the limbs of the radiant young woman whose voice he never hears? . . .

In the modernized form of the most luxurious of industries the mannequin, survivor of volup-tuous barbarism, is like a victim loaded with spoils. She is the prey of shamelessly greedy eyes, the living bait, the passive realization of an idea. Her ambiguous profession confers an equal ambiguity on herself. Verbally, her very sex is dubious. We literally call this charming girl a "little man" (manikin) and her work consists of simulating idleness. A demoralizing occupation keeps her equally remote from her employer and from the ordinary workgirls. Is not all this enough to excuse and justify the mannequin's peculiar tempera-ment and caprices? [No other female vocation

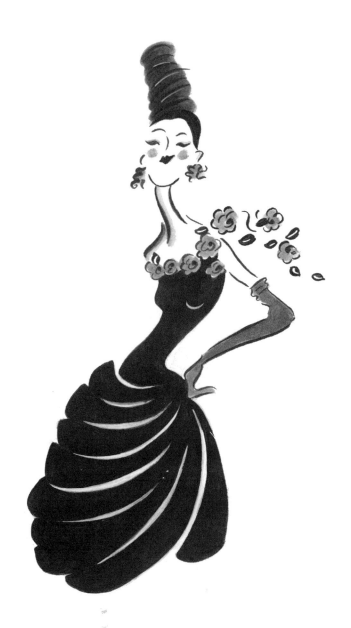

contains such powerful elements of moral disinte-
gration as hers, imposing on a poor, beautiful
girl the exterior signs of wealth.]

 [As for you,] moguls of the dress-world . . .
you will continue to put up with . . . the capri-
cious creature's . . . neurasthenia, her nervous
yawns, her bursts of tears, her sudden listlessness,
her momentary brilliance that singles her out
for homage. . . . You will, in fact, put up with
everything you tolerate, everything you excuse,
everything you respect in her greater brother,
the artist. — COLETTE
 1873–1954

the tyranny of fashion

Fashion is more powerful than any tyrant.

— SAYING (Latin)

Fashion, *n*. A despot whom the wise ridicule and
obey. — AMBROSE BIERCE

1842 – c. 1914

Judging from the ugly and repugnant things that
are sometimes in vogue, it would seem as though
fashion were desirous of exhibiting its power by
getting us to adopt the most atrocious things for
its sake alone. — GEORG SIMMEL

1858–1918

Fashion makes fools of some, sinners of others,
and slaves of all. — JOSH BILLINGS

1818–1885

It is amusing to observe in every age the ingenuity
of dress in changing the human figure.

— HANNAH FARNHAM LEE

1780–1865

Fantastic garbs . . . succeed each other, like monster devouring monster in a dream.

— THOMAS CARLYLE
1795–1881

the mutability of fashion

The same costume will be
Indecent . . . 10 years before its time
Shameless . . . 5 years before its time
Outré (daring) . . . 1 year before its time
Smart
Dowdy . . . 1 year after its time
Hideous . . . 10 years after its time
Ridiculous . . . 20 years after its time
Amusing . . . 30 years after its time
Quaint . . . 50 years after its time
Charming . . . 70 years after its time
Romantic . . . 100 years after its time
Beautiful . . . 150 years after its time.

—JAMES LAVER
1899–1975

Fashion always occupies the dividing-line between
the past and the future, and consequently conveys
a stronger feeling of the present, at least while it
is at its height, than most other phenomena.

—GEORG SIMMEL
1858–1918

Fashion is an odd jumble of contradictions, of sympathies and antipathies. It exists only by its being participated among a certain number of persons, and its essence is destroyed by being communicated to a greater number. It is a continual struggle between "the great vulgar and the small" to get the start of or keep up with each other in the race of appearances, by an adoption on the part of the one of such external and fantastic symbols as strike the attention and excite the envy or admiration of the beholder, and which are no sooner made known and exposed to public view for this purpose, than they are successfully copied by the multitude, the slavish herd of imitators, who do not wish to be behind-hand with their betters in outward show and pretensions, and which then sink, without any further notice, into disrepute and contempt. Thus fashion lives only in a perpetual round of giddy innovation and restless vanity. To be old-fashioned is the greatest crime a coat or a hat can be guilty of. To look like nobody else is a sufficiently mortifying reflection; to be in danger of being mistaken for one of the rabble is worse. Fashion constantly begins and ends in the two things it abhors most, singularity and vulgarity. —WILLIAM HAZLITT
1778–1830

The economic logic of fashion depends on making the old-fashioned look absurd.

—JOHN BERGER
b. 1926

Fashion dies very young, so we must forgive it everything.

—JEAN COCTEAU
1889–1963

As any fleeting fashion in dress comes to be admired by man, so with birds a change of almost any kind in the structure or colouring of the feathers in the male appears to have been admired by the female.

—CHARLES DARWIN
1809–1882

Fashions are like human beings. They come in, nobody knows when, why, or how; and they go out, nobody knows when, why, or how.

—CHARLES DICKENS
1812–1870

People don't change. Only their costumes do.

—GENE MOORE
1910–1998

The pedant who considers fashion idiotic on account of its transitoriness commits a sin against

life. Fashion is in fact a symbol of life itself, which showers its gifts fickly, wastefully, without calculating timidly whether the effort stands in a sensible relationship to that which is achieved. Nature strews thousands of seed everywhere. Perhaps one will sprout. It is precisely this extravagance of thought, this eternal beginning, this colorful richness that makes fashion so pleasurable.

—AUGUST ENDELL
1872–1925

secondhand clothes

Often have I turned into [London's] old-clothes
market to worship. With awe-struck heart I walk
through . . . Monmouth Street, with its empty
suits. . . . Silent are they, but expressive in their
silence: the past witnesses and instruments of woe
and joy, of passions, virtues, crimes, and all the
fathomless tumult of good and evil in "the prison
called life." Friends! trust not the heart of that
man for whom old clothes are not venerable.

— THOMAS CARLYLE
1795–1881

It is not uncommon to refuse to dress in "used
clothing"; in some cultures it is unthinkable to
wear the clothing of the dead. In other situations,
continuing associations with an original wearer
are eagerly sought, investigated, even treasured.
In any case, the claim to another, previous life is
unshakable. — CLAUDIA GOULD
b. 1956

You can't know how I dreaded appearing in school
in those miserable poor-box dresses. I was perfectly

sure to be put down in class next to the girl who
first owned my dress, and she would whisper and
giggle and point it out to the others. The bitterness
of wearing your enemies' cast-off clothes eats into
your soul. If I wore silk stockings for the rest of
my life, I don't believe I could obliterate the scar.

— JEAN WEBSTER
1876–1916

I was very thin, because I had no money to eat
properly, and because what little money I had I
used to buy clothes. Being very thin, however,
I looked good in clothes. I loved the way I looked
all dressed up. I bought hats, I bought shoes, I
bought stockings and garter belts to hold them up.
I bought handbags, I bought suits, I bought
blouses, I bought dresses, I bought skirts, and I
bought jackets that did not match the skirts. I used
to spend hours happily buying clothes to wear.
Of course, I could not afford to buy my clothes in
an actual store, a department store. Instead, they
came from used-clothing stores, and they were
clothes of a special kind, stylish clothes from
a long-ago time — twenty or thirty or forty years
earlier. They were clothes worn by people who were
alive when I had not been; by people who were
far more prosperous than I could imagine being.

As a result, it took me a long time to get dressed, for I could not easily decide what combination of people, inconceivably older and more prosperous than I was, I wished to impersonate that day. It was sometimes hours after I started the process of getting dressed that I finally left my house and set off into the world.　　—JAMAICA KINCAID
b. 1949

What the support for flea-marketry represents more, perhaps, than affection for the secondhand is the desire to find style, but obliquely, and splendor, but tackily, and so put an ironic distance between the wearers and the fashionableness of their clothes.　　—KENNEDY FRASER
b. 1946

A past style in clothes often looks absurd until it is re-incorporated into fashion.　　—JOHN BERGER
b. 1926

fashion as history

Show me the clothes of a country and I can write
its history. — ANATOLE FRANCE
1844–1924

The creative part of fashion has always worked
alongside the creative forces that have defined and
colored a decade, an era. As much as art, fashion
is a manifestation of the times — of its psychologi-
cal, social, political, visual existence
— IRENE SHARAFF
c. 1910–1993

Fashion is born by small facts, trends, or even
politics, never by trying to make little pleats and
furbelows, by trinkets, by clothes easy to copy, or
by the shortening or lengthening of a skirt.
— ELSA SCHIAPARELLI
1890–1973

We can discover one of the reasons why in these
latter days fashion exercises such a powerful influ-
ence on our consciousness in the circumstance that
the great, permanent, unquestionable convictions

are continually losing strength, as a consequence
of which the transitory and vacillating elements
of life acquire more room for the display of their
activity. — GEORG SIMMEL
1858–1918

In an epoch as somber as ours, one must fight for
luxury inch by inch. — CHRISTIAN DIOR
1905–1957

MAN IN BARBERSHOP: Lately you look quite
fashionable.
KIHACHI: It's the times.
— JAMES MAKI [YASUJIRO OZU]
1903–1963
TADAO IKEDA
1905–1964

She was enveloped by her clothes as if by the deli-
cate, distilled apparatus of an entire civilization.
— MARCEL PROUST
1871–1922

fashion as art

Fashion is a craft, and an expression of a period
of time, but it is not an art.　— BILL BLASS
b. 1922

Curiously, many of the same creative forces are
brought into play both in fashion and art. Stan-
dards of proportion, of measure, and of simplicity
are as important to a dressmaker as to a painter.
But those who work within fashion's sphere have
been charmed by time and change, by the desire,
above all, to be chic. They are playing a game with
themselves, often a tragic game. The immediate
effect is more important to them than anything
else; creating something that will reflect the
moment is more essential than creating something
outside the time stream. The more the fashion-
monger enjoys this game of artifice, the more deca-
dent he becomes. This does not mean that an artist
cannot create in this medium to a brilliant effect:
he can. . . . But none can play fashion's game and
be entirely true artists at the same time . . . for . . .
they have built their lives on shifting sands.

— CECIL BEATON
1904–1980

The ineluctable movement of fashion had its
origins as a form of presumption—the desire to
imitate and resemble something better, more free,
more beautiful and shining, which one could
not actually aspire to be. —ANNE HOLLANDER
b. 1930

Dress designing . . . is to me not a profession but
an art. I found that it was a most difficult and
unsatisfying art, because as soon as a dress is born
it has already become a thing of the past. As often
as not too many elements are required to allow
one to realize the actual vision one had in mind.
The interpretation of a dress, the means of mak-
ing it, and the surprising way in which some
materials react—all these factors, no matter how
good an interpreter you have, invariably reserve
a slight if not bitter disappointment for you. In a
way it is even worse if you are satisfied, because
once you have created it the dress no longer belongs
to you. A dress cannot just hang like a painting
on the wall, or like a book remain intact and live
a long and sheltered life.
 A dress has no life of its own unless it is worn,
and as soon as this happens another personality
takes over from you and animates it, or tries to,
glorifies it or destroys it, or makes it into a song

of beauty. More often it becomes an indifferent object, or even a pitiful caricature of what you wanted it to be—a dream, an expression.

— ELSA SCHIAPARELLI
1890–1973

Enter the ateliers of the great couturiers and you will feel that you're not in a shop but in the studio of an artist who intends to make of your dress a portrait of yourself, and one that resembles you.

— PAUL POIRET
1879–1944

Fashion is a branch of the visual and performing arts.

— CAMILLE PAGLIA
b. 1947

For [Madeleine] Vionnet . . . couture is not a minor art. Like the dance it is an evanescent art, but a great one.

— BRUCE CHATWIN
1940–1989

Fiat modes, pereat ars (Let There Be Fashion, Down With Art)

— MAX ERNST
1891–1976

color in dress

When in doubt, wear red.

— BILL BLASS
b. 1922

I can't imagine becoming bored with red—
it would be like becoming bored with the person
you love. — DIANA VREELAND
1906–1989

Purple—is fashionable twice—
This season of the year,
And when a soul perceives itself
To be an Emperor.

—EMILY DICKINSON
1830–1886

I work in three shades of black.

— REI KAWAKUBO
b. 1942

Red is black.

— REI KAWAKUBO
b. 1942

Pink is the navy blue of India.

— DIANA VREELAND
1906–1989

Now Israel loved Joseph more than all his children, because he was the son of his old age: and he made him a coat of many colours.

— GENESIS 37:3
King James Version (1611)

Style

One wants to be *very* something, *very* great, *very* heroic; or if not that, then at least very stylish and very fashionable.
— HARRIET BEECHER STOWE
1811–1896

Fashion can be bought. Style one must possess.
— EDNA WOOLMAN CHASE
1877–1954

Fashion can make you ridiculous; style, which is yours to control individually, can make you attractive—a near siren.
— MARIANNE MOORE
1887–1972

Style ain't nothing but keeping the same idea from beginning to end. Everybody got it.
— AUGUST WILSON
b. 1945

The energy of imagination, deliberation, and invention, which fall into a natural rhythm totally one's own, maintained by innate discipline and

a keen sense of pleasure—these are the ingredients of style. And all who have it share one thing: originality. —DIANA VREELAND
1906–1989

Style is not something applied. It is something inherent, something that permeates. It is of the nature of that in which it is found, whether the poem, the manner of a god, the bearing of a man. It is not a dress. —WALLACE STEVENS
1879–1955

the street

Once it was power that created style. But now high styles come from low places, from people who carve out worlds for themselves in the nether depths, in tainted "undergrounds." — TOM WOLFE
b. 1931

The pursuit of Fashion is the attempt of the middle class to co-opt tragedy.

In adopting the clothing, speech, and personal habits of those in straitened, dangerous, or pitiful circumstances, the middle class seeks to have what it feels to be the exigent and nonequivocal experiences had by those it emulates.

In progressing from an emulation of the *romantic* to an emulation of the *tragic,* the middle class unconsciously avows not only the aridity of its lifestyle, but the complete failure of its fantasies, and of its very ability to fantasize.

We dress in the denim of the farm worker and the prisoner of the state, the olive drab and khaki of the field soldier, the gray and blue of the Chinese laborer, the beaten leather jackets of the bread line. . . .

The very fact of something being beyond the experience of the middle class is sufficient to ratify that something in its eyes. In pursuing the tragic we gainsay our own too-sad intelligence, our increasingly worthless common sense, in favor of that which is beyond our experience and, therefore, *possibly* productive. —DAVID MAMET
b. 1947

All chic is now gutter chic.
—ELIZABETH WILSON
b. 1936

I like fashion to go down into the street, but I can't accept that it should originate there.
—GABRIELLE ("COCO") CHANEL
1883–1971

indigenous dress

There is always a certain pleasure in contemplating the costume of a distant nation.

—*Edinburgh Review* (1802)

A [regional] costume is clothing that has frozen in a particular form; it will develop no further. It is always a sign that its wearer has given up trying to change his circumstances. The costume is the symbol of resignation. — A D O L F L O O S
1870–1933

Fashion, as we know it in the West, is not and never was a universal condition of dress. It is a European product and is not nearly as old as European Civilisation. — Q U E N T I N B E L L
1910–1996

dressing for effect

The first purpose of clothes . . . was not warmth
or decency, but ornament. . . . Among wild peo-
ple, we find tattooing and painting even prior
to clothes. The first spiritual want of a barbarous
man is decoration; as indeed we still see among
the barbarous classes in civilized countries.

— THOMAS CARLYLE
1795–1881

"I like the way old Grover dresses," Captain Charley
said. "He dresses like he means it."

— JOSEPH MITCHELL
1908–1996

parading dress

The theatrical impulse to dress up and participate
in special occasions has deeply affected people's
lives. The wearing of special clothing in the sight
of other people has in fact often been arranged
to constitute a complete theatrical event in
itself. To make a show with clothes, without the
demands of song or dance or spoken text, is a
way of permitting ordinary citizens to be spectac-
ular performers without any talent whatsoever.
Physical beauty is not necessary, either. A simple
public procession of specially dressed-up ordinary
people is one of the oldest kinds of shows in the
world; it has probably continued to exist because
it never fails to satisfy both those who watch and
those who walk. — ANNE HOLLANDER
b. 1930

Style won't be interesting again until more people
are willing to show off on the street. Suburbs
don't have streets, and city streets are perilous —
but nothing is as interesting as street clothes
when the wind is blowing and the sun is out, or

the rain is dramatic, and everyone you pass is
playing the carnal game with you.

— HAROLD BRODKEY
1930–1996

Women fond of dress are hardly ever entirely
satisfied not to be seen, except among the insane;
usually they want witnesses.

— SIMONE DE BEAUVOIR
1908–1986

dishevelment

A sweet disorder in the dress
Kindles in clothes a wantonness:
A lawn about the shoulders thrown
Into a fine distraction:
An erring lace, which here and there
Enthrals the crimson stomacher:
A cuff neglectfull, and thereby
Ribbands to flow confusedly:
A winning wave (deserving note)
In the tempestuous petticoat:
A careless shoe-string, in whose tie
I see a wild civility:
Do more bewitch me than when Art
Is too precise in every part.

— ROBERT HERRICK
1591–1674

Some ladies think they may, under the privileges
of the *déshabillé,* be loose and negligent of their
dress in the morning. But be you, from the
moment you rise till you go to bed, as cleanly and
properly dressed as at the hours of dinner or tea.

— THOMAS JEFFERSON
1743–1826

When you are once well dressed for the day think no more of it afterwards; and without any stiffness for fear of discomposing that dress, let all your motions be as easy and natural as if you had no clothes on at all.

— PHILIP DORMER STANHOPE
fourth earl of Chesterfield
1694–1773

I have always a sacred veneration for anyone I observe to be a little out of repair in his person, as supposing him either a poet or a philosopher.

— JONATHAN SWIFT
1667–1745

A negligent dress is becoming to men.

— OVID
43 B.C.– A.D. 17

Elegance should have an ill-dressed air.

— RAYMOND RADIGUET
1903–1923

The more careless, the more modish.

— JONATHAN SWIFT
1667–1745

Pure style in clothes is as intimidating as pure style
in anything else. — ELIZABETH BOWEN
1899–1973

She was a curious woman, whose dresses always
looked as if they had been designed in a rage and
put on in a tempest. . . . She tried to look pictur-
esque, but only succeeded in being untidy.

— OSCAR WILDE
1854–1900

His clothes fit him so ill, and constrain him so
much, that he seems rather their prisoner than
their proprietor.

— PHILIP DORMER STANHOPE
fourth earl of Chesterfield
1694–1773

She wears her clothes as if they were thrown on
her with a pitchfork. — JONATHAN SWIFT
1667–1745

Many there are, who seem to slight all care,
And with a pleasing negligence ensnare;
Whole mornings oft, in such a dress are spent,
And all is art, that looks like accident.

— OVID
43 B.C.–A.D. 17

decorum

A plain, genteel dress is more admired, and obtains more credit, than lace and embroidery, in the eyes of the judicious and sensible.

— GEORGE WASHINGTON
1732–1799

A man of sense carefully avoids any particular character in his dress; he is accurately clean for his own sake; but all the rest is for other people's. He dresses as well, and in the same manner, as the people of sense and fashion of the place where he is. If he dresses better, as he thinks, that is, more then they, he is a fop; if he dresses worse, he is unpardonably negligent.

— PHILIP DORMER STANHOPE
fourth earl of Chesterfield
1694–1773

Let women adopt that chaste and simple, that neat and elegant style of dress, which so advantageously displays the charms of real beauty, instead of those preposterous fashions and fantastical draperies of dress which, while they conceal some few defects of person, expose so many defects of mind, and sacrifice to ostentatious finery all those mild, amiable, and modest virtues, by which the female character is so pleasingly adorned.

— TERTULLIAN
155 to 160 — after 220

In olden days, a glimpse of stocking
Was looked on as something shocking,
But now, God knows,
Anything goes.

— COLE PORTER
1891–1964

I think [American women] look best when they
are immaculately scrubbed and exquisitely
groomed. They always ought to wear white gloves
and pearls and own one good dress.

— NORMAN NORELL
1900–1972

The average woman should limit herself to the
costumes worn by the heroines of light comedies
laid in moderate-sized towns. — ADRIAN
1903–1959

The best-dressed woman is one whose clothes
wouldn't look too strange in the country.

— HARDY AMIES
b. 1909

There is nothing touches our imagination so
much as a beautiful woman in a plain dress.

— JOSEPH ADDISON
1672–1719

It is almost as stupid to let your clothes betray that
you know you are ugly as to have them proclaim
that you think you are beautiful.

— EDITH WHARTON
1862–1937

A gentleman's taste in dress is, upon principle,
the avoidance of all things extravagant; it consists
in the quiet simplicity of exquisite neatness.

— EDWARD GEORGE EARLE BULWER-LYTTON

first baron Lytton

1803–1873

I hold that gentleman to be the best dressed
whose dress no one observes.

— ANTHONY TROLLOPE

1815–1882

artifice

Still to be neat, still to be dressed,
As you were going to a feast;
Still to be powdered, still perfumed:
Lady it is to be presumed,
Though art's hid causes are not found,
All is not sweet, all is not sound.

Give me a look, give me a face
That makes simplicity a grace;
Robes loosely flowing, hair as free:
Such sweet neglect more taketh me
Than all the adulteries of art;
They strike mine eyes, but not my heart.

— BEN JONSON
1572–1637

The greatest beauty in female dress is that which
is most simple, and at the same time gracefully
adapted to exhibit the natural beauty of the female
form. — GEORGE POPE MORRIS
1802–1864

My dream is to save [women] from nature.

— CHRISTIAN DIOR
1905–1957

The tulip and the butterfly
Appear in gayer coats than I:
Let me be dressed fine as I will,
Flies, worms, and flowers exceed me still.

— ISAAC WATTS
1674–1748

I cannot see why a person should be esteemed
haughty on account of his taste for fine clothes,
any more than one who discovers a fondness for
birds, flowers, moths or butterflies.

— WILLIAM SHENSTONE
1714–1763

Without black velvet breeches, what is man?

— JAMES BRAMSTON
c. 1694–1744

And, e'en while fashion's brightest arts decoy,
The heart distrusting asks, if this be joy.

— OLIVER GOLDSMITH
1730–1774

against ostentation

I went to the marriage of Mademoiselle de Louvois.
What shall I say about it? Magnificence, gorgeous-
ness, all France, garments loaded and slashed with
gold, jewels, a blaze of fires and flowers, a jam of
coaches, cries in the street, torches flaring, poor
folk thrust back and run over; in short, the usual
whirlwind of nothing, questions not answered,
compliments not meant, civilities addressed to no
one in particular, everybody's feet tangled up in
everybody's train.

— MARIE DE RABUTIN-CHANTAL
marquise de Sévigné
1626–1696

As long as there are cold and nakedness in the
land around you, so long can there be no question
at all but that splendor of dress is a crime.

— JOHN RUSKIN
1819–1900

Precious clothing is culpable . . . for its strange
new modes, and its fantastic ornamentation . . .
which . . . makes cloth so dear, to the harm of the

people; not only the cost of the embroidering, the
elaborate notching or barring, the waved lines,
the stripes, the twists, the diagonal bars, and simi-
lar waste of cloth in vanity; but there is also the
costly furring of gowns, so much perforating with
scissors to make holes, so much slashing with
shears; and then the superfluity in length of the
aforesaid gowns, trailing in the dung and in the
mire, a-horseback and afoot, as well of man's
clothing as of woman's, until all this trailing verily,
in its effect, wastes, consumes, makes threadbare
and rotten with dung the superfluity that rather
should be given to the poor.

— GEOFFREY CHAUCER
c. 1342–1400

I made my song a coat
Covered with embroideries
Out of old mythologies
From heel to throat;
But the fools caught it,
Wore it in the world's eyes
As though they'd wrought it.
Song, let them take it,
For there's more enterprise
In walking naked.

— W. B. YEATS
1865–1939

nudity

Nakedness reveals itself. Nudity is placed on display. . . . The nude is condemned to never being naked. Nudity is a form of dress.

—JOHN BERGER
b. 1926

And the eyes of them both were opened, and they knew that they were naked; and they sewed fig leaves together, and made themselves aprons.

—GENESIS 3:7
King James Version (1611)

We see the professionals of striptease wrap themselves in the miraculous ease which constantly clothes them, makes them remote, gives them the icy indifference of skilful practitioners, haughtily taking refuge in the sureness of their technique: their science clothes them like a garment.

—ROLAND BARTHES
1915–1980

Today let us honor . . .

.

. . . the Victorian lady
in love who has removed her hood, her cloak,
her laced boots, her stockings, her overdress,
her underdress, her wool petticoat, her linen
petticoats, her silk petticoats, her whalebone
corset, her bustle, her chemise, her drawers, and
who still wants to!　　　　　— MARGE PIERCY
b. 1936

Her vespers done,
Of all its wreathed pearls her hair she frees;
Unclasps her warmed jewels one by one;
Loosens her fragrant bodice; by degrees
Her rich attire creeps rustling to her knees.
— JOHN KEATS
1795–1821

Full nakedness! All joys are due to thee,
As souls unbodied, bodies unclothed must be,
To taste whole joys.　　　　— JOHN DONNE
1572–1631

Stripped of the cunning artifices of the tailor, and
standing forth in the garb of Eden—what a sorry

set of round-shouldered, spindle-shanked, crane-necked varlets would civilized men appear!

— HERMAN MELVILLE
1819–1891

[Man] is by nature a *naked animal;* and only in certain circumstances, by purpose and device, masks himself in clothes.

— THOMAS CARLYLE
1795–1881

The finest clothing made is a person's skin, but, of course, society demands something more than this.

— MARK TWAIN
1835–1910

If for any reason the body must be clothed, the clothing should be to the body as nearly as possible what the body is to the spirit.

— HENRY HOLIDAY
1839–1927

No woman so naked as one you can see to be naked underneath her clothes.

— MICHAEL FRAYN
b. 1933

You accuse her of being ill-dressed. I agree.
Clothes don't become her. Everything that hides
her, disfigures. It is in the freedom of dishabille
that she is truly ravishing.

— PIERRE CHODERLOS DE LACLOS
1741–1803

Clothes, even when omitted, cannot be escaped.

— ANNE HOLLANDER
b. 1930

dandyism

A dandy is a clothes-wearing man, a man whose trade, office, and existence consists in the wearing of clothes. Every faculty of his soul, spirit, purse, and person is heroically consecrated to this one object, the wearing of clothes wisely and well: so that as others dress to live, he lives to dress.

— THOMAS CARLYLE
1795–1881

Dandyism does not even consist, as many thoughtless people seem to believe, in an immoderate taste for the toilet and material elegance. For the perfect dandy these things are no more than symbols of his aristocratic superiority of mind.

— CHARLES BAUDELAIRE
1821–1867

The role of the dandy implied an intense preoccupation with self and self presentation; image was everything, and the dandy a man who often had no family, no calling, apparently no sexual life, no visible means of financial support. He was the very archetype of the new urban man who came

from nowhere and for whom appearance was
reality. — ELIZABETH WILSON
b. 1936

He had no advantage of birth, and but little of
fortune. . . . His beauty, of figure rather than of
face, was marred by a broken nose. Yet without a
single noble, important, or valuable action to his
credit he cuts a figure; he stands for a symbol;
his ghost walks among us still. The reason for this
eminence is now a little difficult to determine.
Skill of hand and nicety of judgment were his, of
course, otherwise he would not have brought the
art of tying neck-cloths to perfection. The story is,
perhaps, too well known — how he drew his head
far back and sunk his chin slowly down so that
the cloth wrinkled in perfect symmetry, or if one
wrinkle were too deep or too shallow, the cloth was
thrown into a basket and the attempt renewed,
while the Prince of Wales sat, hour after hour,
watching. Yet skill of hand and nicety of judgment
were not enough. Brummell owed his ascendency
to some curious combination of wit, of taste,
of insolence, of independence — for he was never
a toady — which it were too heavy handed to call
a philosophy of life, but served the purpose.
— VIRGINIA WOOLF
1882–1941

The grace of his carriage was so astonishing; his bows were so exquisite. Everybody looked over-dressed or badly dressed—some, indeed, looked positively dirty beside him. His clothes seemed to melt into each other with the perfection of their cut and the quiet harmony of their colour. Without a single point of emphasis everything was distinguished—from his bow to the way he opened his snuff-box, with his left hand invariably. He was the personification of freshness and cleanliness and order. —VIRGINIA WOOLF
1882–1941

Dandyism is a state of being composed entirely of nuances—as always occurs in extremely old and extremely civilized societies.

—JULES AMÉDÉE BARBEY D'AUREVILLY
1808–1889

In all known images of the Beau, we are struck by the utter simplicity of his attire. . . . Is it not to his fine scorn of accessories that we may trace that first aim of modern dandyism, the production of the supreme effect through means the least extravagant? In certain congruities of dark cloth, in the rigid perfection of his linen, in the symmetry of his glove with his hand, lay the secret of Mr. Brummell's miracles. He was ever most eco-

nomical, most scrupulous of means. Treatment
was everything with him. . . . Mr. Brummell was,
indeed, in the utmost sense of the word, an
artist. — MAX BEERBOHM
 1872–1956

It can be seen how, at certain points, dandyism
borders upon the spiritual and the stoical. . . .
For those who are at once its priests and its
victims, all the complicated material conditions
to which they submit . . . are no more than a
system of gymnastics designed to fortify the
will and discipline the soul. In truth I was not
altogether wrong to consider dandyism as a
kind of religion. — CHARLES BAUDELAIRE
 1821–1867

Thrice every day of the year did he dress, and
three hours were the average of his every toilet,
and other hours were spent in council with
the cutter of his coats or with the custodian of
his wardrobe. A single, devoted life!
 — MAX BEERBOHM
 1872–1956

The question is of the greatest seriousness —
Should I go to Douai with a top hat or a soft one?

I haven't been able to sleep for two nights. Please
reply by telegram. — GIOVANNI BOLDINI
1842–1931

The summer evenings were long. It was not dark
yet. Presently Tom checked his whistle. A stranger
was before him; a boy a shade larger than him-
self. A newcomer of any age or either sex was an
impressive curiosity in the poor little village of
St. Petersburg. This boy was well dressed, too —
well dressed on a week-day. This was simply
astounding. His cap was a dainty thing, his close-
buttoned blue cloth roundabout was new and
natty, and so were his pantaloons. He had shoes
on, and yet it was only Friday. He even wore a
neck-tie, a bright bit of ribbon. He had a citified
air about him that ate into Tom's vitals. The more
Tom stared at the splendid marvel, the higher
he turned up his nose at his finery, and the shab-
bier and shabbier his own outfit seemed to him to
grow. Neither boy spoke. If one moved the other
moved — but only sidewise, in a circle. They kept
face to face and eye to eye all the time. Finally,
Tom said:

"I can lick you!" — MARK TWAIN
1835–1910

feminism and dress

A woman should be an illusion. — IAN FLEMING
1908–1964

It is probable that the juxtaposition of the exces-
sively serious and the excessively frivolous, which is
the basis for the rhetoric of Fashion, merely repro-
duces, on the level of clothing, the mythic situation
of Women in Western civilization, at once sublime
and childlike. — ROLAND BARTHES
1915–1980

Isn't that the problem? That women have been
swindled for centuries into substituting adornment
for love, fashion (as it were) for passion?
 — ERICA JONG
b. 1942

My husband gave up everything for me. I'm not a
beautiful woman. I'm nothing to look at, so the
only thing I can do is dress better than anyone else.
If everyone looks at me when I enter a room, my
husband can feel proud of me. That's my chief
responsibility. — WALLIS WARFIELD
duchess of Windsor
1896–1986

Thou hast lived with me
These forty years; we have grown old together,
As many ladies and their women do,
With talking nothing, and with doing less:
We have spent our life in that which least concerns life,
Only in putting on our clothes.

—JOHN WEBSTER
c. 1580–c. 1632

Taught from infancy that beauty is woman's sceptre,
the mind shapes itself to the body, and roaming
round its gilt cage, only seeks to adorn its prison.

—MARY WOLLSTONECRAFT
1759–1797

One of the chief obstacles in the way of woman's
elevation to the same platform of human rights,
and moral dignity, and intellectual improvement,
with her brother, on which God placed her . . . is
her love of dress. —SARAH MOORE GRIMKÉ
1792–1873

Our only hope for the redemption of woman
from the thralldom of dress lies in the belief that
her hitherto limited sphere of activities has been
so insufficient for her intellectual occupations
that she has been forced to expend her thoughts in

decorating her person, instead of enlarging her
mind. — MERCY B. JACKSON
 1802–1877

I believe in women; and in their right to their
own best possibilities in every department of life.
I believe that the methods of dress practiced
among women are a marked hindrance to the
realization of these possibilities, and should be
scorned or persuaded out of society.
 — ELIZABETH STUART PHELPS WARD
 1844–1911

The most casual observer could see how many
pleasures young girls were continually sacrificing
to their dress: In walking, running, rowing, skat-
ing, dancing, going up and down stairs, climbing
trees and fences, the airy fabrics and flowing skirts
were a continual impediment and vexation. We
can not estimate how large a share of the ill-health
and temper among women is the result of the
crippling, cribbing influence of her costume.
 — ELIZABETH CADY STANTON
 1815–1902

The costume of women should be suited to her
wants and necessities. It should conduce at once to

her health, comfort, and usefulness; and,
while it should not fail also to conduce
to her personal adornment, it should
make that end of secondary importance.

—AMELIA JENKS BLOOMER
1818–1894

Is fashionable dress part of the oppres-
sion of women, or is it a form of adult
play? —ELIZABETH WILSON
b. 1936

Every woman is entitled to her inde-
pendence. It is her right to dress con-
spicuously or modestly as she chooses.
It is her right to ignore the dictates of
fashion and dress in a manner that is
becoming to her own character and
personality. In these days when women
are being granted the vote everywhere,
we hear she is at last man's equal but
she will not achieve her true equality
until she breaks the chains of fashion's
tyranny and strides out on her own.

—LILLIE LANGTRY
1853–1929

I am thrilled to be writing a report on such a deli-
cate subject as trousers, and thus to be licensed
to plunge into meditation upon them; even as
I write, a desirous grin, I can feel it, is spreading
over my entire face. Women are, and always will
be, so delicious. Well then, as regards fashion in
trousers, tending as it does to excite all hearts and
minds, and to quicken every pulse, that fashion
must conduct the thought of any earnestly think-
ing man above all toward that which it accentuates
and importantly clothes: the leg. The leg of the
woman is thereby, to some extent, moved into
a more luminous foreground. Anyone who loves,
esteems, and admires women's legs, as I do, can
consequently, it would seem, only concur with
such a fashion, and indeed I do concur with it,
although I am actually very much in favor of skirts
also. A skirt is noble, awe-inspiring, and has a
mysterious character. Trousers are incomparably
more indelicate and they suffuse the masculine
soul, to some extent, with a shudder. Again, on the
other hand, why should horror not grip us mod-
ern people, slightly? It seems to me that we do very
much need to be woken up, to be given a shake.

— ROBERT WALSER
1878–1956

cross-dressing

The woman shall not wear that which pertaineth unto a man, neither shall a man put on a woman's garment: for all that do so are abomination unto the Lord thy God. —DEUTERONOMY 22:5
King James Version (1611)

Cross dressing has often been the sign of an extraordinary destiny. In many shamanistic cultures, transvestites are regarded as sorcerers or visionaries, who, because of their double nature as men dressed as women, are sources of divine authority within the community. —PETER ACKROYD
b. 1948

Q: How does doing drag make you feel?
A: I feel like Superman. It's very empowering. You become the God of your own imagination.
—RUPAUL
b. 1960

Laying her pen aside [Orlando] went into her bedroom, stood in front of her mirror, and arranged her pearls about her neck. Then since

pearls do not show to advantage against a morning gown of sprigged cotton, she changed to a dove grey taffeta; thence to one of peach bloom; thence to a wine-coloured brocade. Perhaps a dash of powder was needed, and if her hair were disposed— so—about her brow, it might become her. Then she slipped her feet into pointed slippers, and drew an emerald ring upon her finger. "Now," she said when all was ready and lit the silver sconces on either side of the mirror. What woman would not have kindled to see what Orlando saw then burning in the snow—for all about the looking-glass were snowy lawns, and she was like a fire, a burning bush, and the candle flames about her head were silver leaves; or again, the glass was green water, and she a mermaid, slung with pearls, a siren in a cave singing so that oarsmen leant from their boats and fell down, down to embrace her; so dark, so bright, so hard, so soft, was she, so astonishingly seductive that it was a thousand pities that there was no one there to put it in plain English, and say outright, "Damn it Madam, you are loveliness incarnate," which was the truth. Even Orlando (who had no conceit of her person) knew it, for she smiled the involuntary smile which women smile when their own beauty, which seems not their own, forms like a drop falling or a

fountain rising and confronts them all of a sudden in the glass—this smile she smiled and then she listened for a moment and heard only the leaves blowing and the sparrows twittering, and then she sighed, "Life, a lover," and then she turned on her heel with extraordinary rapidity; whipped her pearls from her neck, stripped the satins from her back, stood erect in her neat black silk knicker-bockers of an ordinary nobleman, and rang the bell. When the servant came, she told him to order a coach and six to be in readiness instantly. She was summoned by urgent affairs to London.

—VIRGINIA WOOLF
1882–1941

the erotic power of dress

The greatest provocations of lust are from our apparel. —ROBERT BURTON
1577–1640

Almost every man looks more so in a belted trench coat. —SYDNEY J. HARRIS
1917–1986

Clothes make women make a fool of me. —LORENZ HART
1895–1943

For your own sake you should give her a new gown; for variety of dresses, rouses desire, and makes an old mistress seem every day a new one. —WILLIAM WYCHERLEY
1640–1716

It has been manifest to all serious students of dress that of all the motives for the wearing of clothes, those connected with the sexual life have an altogether predominant position. —J. C. FLÜGEL
1884–1955

When she left the bath, and the silvery drops and the roseate light rippled down her body, I was seized with silent rapture. I wrapped the linen sheets about her, drying her glorious body. The calm bliss remained with me, even now when one foot upon me as upon a footstool, she rested on the cushions in her large velvet cloak. The lithe sables nestled desirously against her cold marble-like body. Her left arm on which she supported herself lay like a sleeping swan in the dark fur of the sleeve, while her left hand played carelessly with the whip.

— LEOPOLD VON SACHER-MASOCH
1836–1895

No fashion is ever a success unless it is used as a form of seduction.　　　— CHRISTIAN DIOR
1905–1957

I chose the most elegant negligee I could find: a delicious one of my own creation. It reveals nothing and suggests everything.

— PIERRE CHODERLOS DE LACLOS
1741–1803

Is not the most erotic part of the body wherever the clothing affords a glimpse?

— ROLAND BARTHES
1915–1980

All such dresses are forbidden which incite irregular desires. —THOMAS WILSON
1663–1755

Seated before the fire . . . O listened to her lover.
. . . What her lover wanted from her was very
simple: that she be constantly and immediately
accessible . . . without the slightest obstacle intervening, and her . . . clothing [was] to bespeak . . .
the symbol of that availability. . . . Tomorrow she
was to go through her closet and sort out her
dresses, and to do the same with her underclothing by going through her dresser drawers. She
would hand over to him absolutely everything
she found in the way of [garter] belts and panties;
the same for any brassieres like the one whose
straps he had had to cut before he could remove
it, any full slips which covered her breasts, all the
blouses and dresses which did not open up the
front, and any skirts too tight to be raised with a
single movement. She was to have other brassieres,
other blouses, other dresses made. . . . She
would find all the money she needed in the little
drawer of her desk. When he had finished speaking, she murmured "I love you."
—PAULINE RÉAGE
1907–1998

The old Baron von Brackel made a long pause. "I think that I must explain to you," he said, "so that you may be able to understand this tale aright, that to undress a woman was then a very different thing from what it must be now. What are the clothes that your ladies of these days are wearing? In themselves as little as possible—a few perpendicular lines, cut off again before they have had time to develop any sense. There is no plan about them. They exist for the sake of the body, and have no career of their own, or, if they have any mission at all, it is to reveal.

"But in those days a woman's body was a secret which her clothes did their utmost to keep. We would walk about in the streets in bad weather in order to catch a glimpse of an ankle, the sight of which must be as familiar to you young men of the present day as the stems of these wineglasses of ours. Clothes then had a being, an idea of their own. With a serenity that it was not easy to look through, they made it their object to transform the body which they encircled, and to create a silhouette so far from its real form as to make it a mystery which it was a divine privilege to solve. The long tight stays, the whalebones, skirts and petticoats, bustle and draperies, all that mass of material under which the women of my day were

buried where they were not laced together as tightly as they could possibly stand it—all aimed at one thing: to disguise.

"Out of a tremendous froth of trains, pleatings, lace, and flounces which waved and undulated, *secundum artem,* at every movement of the bearer, the waist would shoot up like the chalice of a flower, carrying the bust, high and rounded as a rose, but imprisoned in whalebone up to the shoulder. Imagine now how different life must have appeared and felt to creatures living in those tight corsets within which they could just manage to breathe, in those fathoms of clothes which they dragged along with them wherever they walked or sat, and who never dreamed that it could be otherwise, compared to the existence of your young women, whose clothes hardly touch them and take up no room. A woman was then a work of art, the product of centuries of civilization, and you talked of her figure as you talked of her salon, with the admiration which one gives to the achievement of a skilled and untiring artist.

"And underneath all this Eve herself breathed and moved, to be indeed a revelation to us every time she stepped out of her disguise, with her waist still delicately marked by the stays, as with a girdle of rose petals."

—ISAK DINESEN
1885–1962

dress as depravity

Moreover the Lord saith, Because the daughters of Zion are haughty, and walk with stretched forth necks and wanton eyes, walking and mincing as they go, and making a tinkling with their feet:

Therefore the Lord will smite with a scab the crown of the head of the daughters of Zion, and the Lord will discover their secret parts.

In that day the Lord will take away the bravery of their tinkling ornaments about their feet, and their cauls, and their round tires like the moon,

The chains, and the bracelets, and the mufflers,

The bonnets, and the ornaments of the legs, and the headbands, and the tablets, and the earrings,

The rings, and nose jewels,

The changeable suits of apparel, and the mantles, and the wimples, and the crisping pins,

The glasses, and the fine linen, and the hoods, and the vails.

And it shall come to pass, that instead of a sweet smell there shall be stink; and instead of a girdle a rent; and instead of well set hair baldness; and instead of a stomacher a girding of sackcloth; and burning instead of beauty. —ISAIAH 3:16–24

King James Version (1611)

the material world

A crowd had also gathered in the silk department
[of the huge new emporium], the largest crush
being opposite the interior display. . . . At the far
end of the hall, around one of the small cast-iron
columns that supported the expanses of glass,
it was like a stream of fabric, a rippling sheet
falling from above and flaring out as it descended
to the floor. Fine-spun satins and delicate silks
gushed forth first: the satins *à la Reine* and the
Renaissance satins, in the pearly tones of spring
water; lightweight silks with a crystal clarity—Nile
green, Indian azure, May rose, Danube blue.
Then came the more substantial materials: mar-
velous satins, duchess silks—warm-hued, rolling
in great waves. And, at the bottom, as if in the
basin of a fountain, slumbered the heavy fabrics—
the figured weaves, the damasks, the brocades, the
beaded and lamé silks—upon a deep bed of velvet,
all the velvets, black, white, colored, interwoven
with silk or satin, creating with their kaleidoscopic
patches a motionless lake upon which reflections
of sky and landscape seemed to dance. Women,
pale with desire, leaned over as if to see their own

images. They stood, all of them, before this unleashed cataract with a secret fear of being possessed by the outpouring of such luxury and an irresistible desire to plunge into it and be lost there.

— ÉMILE ZOLA
1840–1902

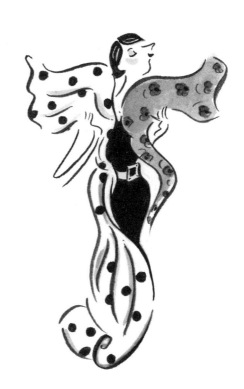

what every woman knows

For my part I delight in women when they go
into a conference huddle over new clothes. They
seem to me then most themselves and the furthest
removed from my sex. They are at such times com-
pletely in their own world. They are half children,
half witches. —J. B. PRIESTLEY
 1894–1984

From the dress-box's plashing tis-
 Sue paper she pulls out her prize,
Dangling it to one side before my eyes
 Like a weird sort of fish

That she has somehow hooked and gaffed
 And on the dock-end holds in air—
Limp, corrugated, lank, a catch too rare
 Not to be photographed.

I, in my chair, make shift to say
 Some bright, discerning thing, and fail,
Proving once more the blindness of the male.
 Annoyed, she stalks away

And then is back in half a minute,
 Consulting, now, not me at all

But the long mirror, mirror on the wall.
 The dress, now that she's in it,

 Has changed appreciably, and gains
 By lacy shoes, a light perfume
Whose subtle field electrifies the room,
 And two slim golden chains.

 With a fierce frown and hard-pursed lips
 She twists a little on her stem
To test the even swirling of the hem,
 Smooths down the waist and hips,

 Plucks at the shoulder-straps a bit,
 Then turns around and looks behind,
Her face transfigured now by peace of mind.
 There is no question—it

 Is wholly charming, it is she,
 As I belatedly remark,
And may be hung now in the fragrant dark
 Of her soft armory.

 — RICHARD WILBUR
 b. 1921

Where's the man could ease a heart
Like a satin gown?

 — DOROTHY PARKER
 1893–1967

"What shall I wear?" is society's second most frequently asked question. The first is, "Do you really love me?" No matter what one replies to either one, it is never accepted as settling the issue.

—JUDITH MARTIN
b. 1938

ball dress

I'm puttin' on my top hat,
Tyin' up my white tie,
Brushin' off my tails. —IRVING BERLIN
 1888–1989

Suddenly the hall burst into life. It was full of
girls, girls who floated in butterfly bright dresses,
hooped out enormously, lace pantalets peeping
from beneath; round little white shoulders bare,
and faintest traces of soft little bosoms showing
above lace flounces; lace shawls carelessly hanging
from arms; fans spangled and painted, fans of
swan's-down and peacock feathers, dangling at
wrists by tiny velvet ribbons; girls with dark hair
smoothed sleekly from ears into chignons so heavy
that their heads were tilted back with saucy pride;
girls with masses of golden curls about their necks
and fringed gold earbobs that tossed and danced
with their dancing curls. Laces and silks and braid
and ribbons, all blockade run, all the more pre-
cious and more proudly worn because of it, finery
flaunted with an added pride as an extra affront
to the Yankees. —MARGARET MITCHELL
 1900–1949

Alas, on pleasure's wild variety
I've wasted too much life away!
But, did they not corrupt society,
I'd still like dances to this day:
the atmosphere of youth and madness,
the crush, the glitter and the gladness,
the ladies' calculated dress.

— ALEKSANDR SERGEYEVICH PUSHKIN

1799–1837

Although her dress, her coiffure, and all the
preparations for the ball had cost Kitty great trou-
ble and consideration, at this moment she walked
into the ballroom in her elaborate tulle dress over
a pink slip as easily and simply as though all the
rosettes and lace, all the minute details of her
attire, had not cost her or her family a moment's
attention, as though she had been born in that
tulle and lace, with her hair done up high on her
head, and a rose and two leaves on the top of it.

When, just before entering the ballroom, the
princess, her mother, tried to turn right side out
the ribbon of her sash, Kitty had drawn back a little.
She felt that everything must be right of itself, and
graceful, and nothing could need setting straight.

It was one of Kitty's best days. Her dress was
not uncomfortable anywhere; her lace bertha did

not droop anywhere; her rosettes were not crushed nor torn off; her pink slippers with high, hollowed-out heels did not pinch, but gladdened her feet; and the thick rolls of fair chignon kept up on her head as if they were her own hair. All the three buttons buttoned up without tearing on the long glove that covered her hand without concealing its lines. The black velvet ribbon of her locket nestled with special softness round her neck. That velvet was delicious; at home, looking at her neck in the looking-glass, Kitty had felt that that velvet was speaking. About all the rest there might be a doubt, but the velvet was delicious. Kitty smiled here too, at the ball, when she glanced at it in the glass. Her bare shoulders and arms gave Kitty a sense of chill marble, a feeling she particularly liked. Her eyes sparkled, and her rosy lips could not keep from smiling from the consciousness of her own attractiveness.

— LEO NIKOLAYEVICH TOLSTOY
1828–1910

mourning costume

Even mourning might be made becoming if no
expense be spared. —ANTHONY TROLLOPE
1815–1882

There [at] the swearing in of Lyndon Johnson on
the president's plane on [the] runway in Dallas,
the woman who had entered the White House as
the youngest first lady left it in the grandest tradi-
tion of all tragic heroines—standing beside the
new president, wearing a dress stained with her
husband's blood. She wore it all the way back to
Washington. And she was still wearing it when she
returned to the White House long after midnight.
"I want them to see what they have done to Jack,"
[she] later explained to the press.
—ANNETTE TAPERT
b. 1956
DIANA EDKINS
b. 1947

MEDVEDÉNKO: Why do you always wear black?
MASHA: I am in mourning for my life.
—ANTON CHEKHOV
1860–1904

uniforms

The connection between dress and war is not far
to seek; your finest clothes are those you wear
as soldiers. — VIRGINIA WOOLF
1882–1941

When I first put this uniform on,
 I said, as I looked in the glass,
 "It's one to a million
 That any civilian
 My figure and form will surpass."
. .

 I said, when I first put it on,
 "It is plain to the veriest dunce
 That every beauty
 Will feel it her duty
 To yield to its glamour at once."
 — W. S. GILBERT
 1836–1911

I always did like a man in uniform. And that one
fits you grand. Why don't you come up sometime
and see me? — MAE WEST
c. 1893–1980

A man becomes the creature of his uniform.

— NAPOLEON I
1769–1821

Every uniform corrupts one's character.

— MAX FRISCH
1911–1991

If you should join us, we will promise you this: when you have put on the Black Shirt, you will become a Knight of Fascism, of a political and spiritual Order. You will be born anew. The Black Shirt is the emblem of new faith that has come to our land.

—*The Blackshirt* (1934)

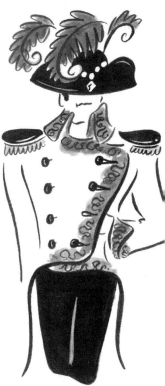

Especially designed gas protection costumes at a reasonable price of 40/-. This outfit is made of pure oiled silk and is available in dawn, apricot, rose, amethyst, Eau de Nil green and pastel pink. The wearer can cover a distance of two hundred yards through mustard gas and the suit can be slipped over

ordinary clothes in thirty-five seconds. A special
pair of mittens is supplied while the hood top is
designed to cover up the head space unprotected
by the ordinary gas mask.

—ADVERTISEMENT

Harvey Nichols and Company of London (1939)

I arrived [at the Leightons'] at a very . . . awful
moment. All Roland's things had just been sent
back from the front. . . . They had just opened
them and they were all lying on the floor. . . .
Everything was damp & worn and simply caked
with mud. . . . The mud of France which covered
them was not ordinary mud; it had not the usual
clean pure smell of earth, but it was as though
it were saturated with dead bodies—dead that had
been dead a long, long time. All the sepulchres
and catacombs of Rome could not make me realise
mortality and decay and corruption as vividly as
did the smell of those clothes. . . . There was his
cap, bent in and shapeless out of recognition—
the soft cap he wore rakishly on the back of his
head—with the badge coated thickly with mud.
He must have fallen on top of it, or perhaps one
of the people who fetched him in trampled on it.
The clothes he was wearing when wounded were

those in which he came home last time. We discovered that the bullet was an expanding one. The hole where it went in in front . . . was almost microscopic, but at the back, almost exactly where his back bone would have been, there was quite a large rent. The under things he was wearing at the time have evidently had to be destroyed, but they sent back a khaki . . . whatever that garment is you wear immediately below your tunic in cold weather . . . which was dark and stiff with blood, and a pair of khaki breeches also in the same state, which had been slit open at the top by someone in a great hurry—probably the Doctor in haste to get at the wound, or perhaps even by one of the men. . . . He must have fallen on his back as in every case the back of his clothes was much more stained & muddy than the front.

The charnel-house smell seemed to grow stronger and stronger till it pervaded the room and obliterated everything else. Finally Mrs Leighton said . . . "Take those clothes away. . . . I must either burn or bury them. They smell of Death; they are not Roland, they even seem to detract from his memory & spoil his glamour. I won't have any more to do with them." And indeed one could never imagine those things the

same as those in which he had lived & walked. One
couldn't believe anyone alive had been in them
at all. — VERA BRITTAIN
1893–1970

May I ask—this is a picturesque uniform, but I'm
not familiar with it—What are you?

— W. S. GILBERT
1836–1911

defying convention

A waistcoat of an intense cerise burst out on his chest; it was buttoned like a doublet under a jacket or frock coat—a bizarre vestment, nameless, fantastically shaped, belonging to no era of the monarchy, the republic, or the empire; trousers in a light color, usually a greenish or rosy gray, completed this costume, which always sent shudders through the bourgeoisie, exasperating to paralysis the nerves of the traditionalists.

— ALEXANDRE DUMAS, *père*
1802–1870

The intoxicating aspect of bad taste lies in the aristocratic pleasure of giving offense.

— CHARLES BAUDELAIRE
1821–1867

His own casual attire . . . had the inconsistency of things at once commonplace and refined which enchants or exasperates the ordinary man because he suspects that it reveals an unconventional existence, a dubious morality, the affectations of the

artist, and, above all, a certain contempt for
established conventions. — G U S T A V E F L A U B E R T
1821–1880

Not being anchored to a firm social position,
the artist and the art student tended to adopt an
experimental attitude towards dress. In the nine-
teenth century when most artists came from the
middle or lower middle classes, it was, quite
logically, the characteristics of his own class which
the artist tended to reject. The middle-class
virtues of tidiness, cleanliness and inconspicuous
decency had to be discarded by one who claimed
to be above class; eccentricity which, in most social
groups, was regarded as a fault was for the artist
a cardinal virtue. — Q U E N T I N B E L L
1910–1996

The fact that the *demi-monde* is so frequently a pio-
neer in matters of fashion is due to its peculiarly
uprooted form of life. The pariah existence to
which society condemns the *demi-monde* produces
an open or latent hatred against everything that
has the sanction of the law, of every permanent
institution, a hatred that finds its relatively most
innocent and aesthetic manifestation in the striv-

ing for ever new forms of appearance. In this continuous striving for new, previously unheard-of fashions, in the regardlessness with which the one that is most diametrically opposed to the existing one is passionately adopted, there lurks an aesthetic expression of the desire for destruction.

— GEORG SIMMEL
1858–1918

All my life . . . I had been fretting against those constrictions of dress which reflected my ancestors' world of rigid social convention. In no way was this reflected more than in their dress. It was my impulse, whenever I found myself alone, to remove my coat, rip off my tie, loosen my collar and roll up my sleeves—a gesture aspiring not merely to comfort but, in a more symbolic sense, to freedom.

— EDWARD
duke of Windsor
1894–1972

People stop and look in amazement at the elegance of this foreigner who walks along unseeing. Like a queen. . . . She's dressed in old European clothes, scraps of brocade, out-of-date old suits, old curtains, old oddments, old models, moth-eaten old

fox furs, old otterskins, that's her kind of beauty, tattered, chilly, plaintive and in exile, nothing suits her, everything's too big, and yet it looks marvelous. — MARGUERITE DURAS
1914–1996

It is not unusual for fashion to adopt the accidental singularity of a person who disapproves of fashions and never suspected that his anarchistic act or his unusual get-up would originate a fad. — JEAN COCTEAU
1889–1963

I talked in a snow-white fulldress, swallow-tail and all, and dined in the same. It's a delightful impudence. I think I will call it my dontcareadam suit. But in the case of the private dinner I will always ask permission to wear it first, saying:

"Dear Madam, may I come in my dontcareadams?" — MARK TWAIN
1835–1910

Bring me the livery of no other man.

I am my own to robe me at my pleasure.

Accepted rules to me disclose no treasure:

What is the chief who shall my garments plan?

No garb conventional but I'll attack it.
(Come, why not don my spangled jacket?)

<div align="right">

— PAUL LAURENCE DUNBAR

1872–1906

</div>

The impulse and the will to carry through an
unorthodox style are no casual matter.

<div align="right">

— KENNEDY FRASER

b. 1946

</div>

nostalgia for clothes

Old clothes are old friends.

—GABRIELLE ("COCO") CHANEL
1883–1971

My old dressing gown—why didn't I keep it? It was
made for me; I was made for it. It hugged all the
contours of my body—but comfortably, without
constriction. In it, I was picturesque and hand-
some. This new one, [scarlet and imperious,] tight
and stiff, makes a mannequin of me.

The old one would lend itself to any service
on my behalf, for poverty is nearly always obliging.
If a book was covered with dust, a fold of my old
dressing gown was ready to wipe it clean. If the ink
thickened and refused to flow from my pen, my
old dressing gown volunteered as a pen-wiper.
These repeated favors were traced on it in long
dark streaks that declared me to be a literary fellow,
a writer, a man who *works*. Now I look like one of
the idle rich; you can't tell who I *am*.

Protected by my old dressing gown, I feared
neither my servant's clumsiness nor my own, neither

sparks from the fire nor leaking water. I was the
absolute master of my old dressing gown; I've
become the slave of the new one.

— DENIS DIDEROT
1713–1784

She had a few handsome dresses left—survivals
of her last phase of splendour. . . . Though they
had lost their freshness, [they] still kept the long,
unerring lines, the sweep and amplitude of the
great artist's stroke; and as she spread them out
on the bed, the scenes in which they had been
worn rose vividly before her. An association
lurked in every fold: each fall of lace and gleam
of embroidery was like a letter in the record of
her past. She was startled to find how the atmos-
phere of her old life enveloped her. . . . She put
back the dresses one by one, laying away with
each some gleam of light, some note of laughter,
some stray waft from the rosy shores of pleasure.

— EDITH WHARTON
1862–1937

Getting ready to sell the house, I went through
the attic and basement and made three piles of
clothes—those to throw out, those to give away,

and those I didn't know what to do with but
couldn't throw out or give away.

<div align="right">

— ILENE BECKERMAN

b. 1935

</div>

I remember almost all the clothes I wore in my
childhood. — HAROLD BRODKEY

<div align="right">

1930–1996

</div>

age and dress

As some fair female unadorned and plain,
Secure to please while youth confirms her reign,
Slights every borrowed charm that dress supplies,
Nor shares with art the triumph of her eyes;
But when those charms are passed, for charms are frail,
When time advances and when lovers fail,
She then shines forth, solicitous to bless,
In all the glaring impotence of dress.
— OLIVER GOLDSMITH
1730–1774

When I am an old woman I shall wear purple
With a red hat which doesn't go, and doesn't suit me,
And I shall spend my pension on brandy and
 summer gloves
And satin sandals, and say we've no money for butter.
— JENNY JOSEPH
b. 1932

She was lonely. That was the thing that made
her seem so garish and caused people to turn their
heads when she went by. Loneliness is a garish qual-

ity, and my grandmother's wardrobe and elaborate toilette appeared flamboyant because they emphasized her isolation. An old woman trying to look young is a common enough sight, but my grandmother was something stranger and sadder—a hermit all dressed up for a gala, a recluse on stubborn parade. — MARY MCCARTHY
1912–1989

Old age slowly gets dressed
Heavily dosed with death's night
Sits on the bed's edge

Pulls its pieces together
Loosely tucks in its shirt

 — TED HUGHES
1930–1998

The Prioress had on a gray taffeta frock with very rare lace, a white lace cap with streamers, and her large old diamond eardrops and brooches. The heroic strength of soul of old women, Boris thought, who with great taste and trouble make themselves beautiful—more beautiful, perhaps than they have ever been as young women—and who still can hold no hope of awakening any desire in the hearts of men, is like that of a right-

eous man working at his good deeds even after he
has abandoned his faith in a heavenly reward.

— ISAK DINESEN
1885–1962

An aged man is but a paltry thing,
A tattered coat upon a stick, unless
Soul clap its hands and sing, and louder sing
For every tatter in its mortal dress.

— W. B. YEATS
1865–1939

animals in clothes

Nothing wears clothes, but Man; nothing doth need
But he to wear them. — GEORGE HERBERT
 1593–1633

Little Lamb, who made thee?
Dost thou know who made thee?
Gave thee life and bid thee feed
By the stream and o'er the mead;
Gave thee clothing of delight,
Softest clothing, woolly bright.

 — WILLIAM BLAKE
 1757–1827

Peter was most dreadfully frightened; he rushed all
over the garden, for he had forgotten the way back
to the gate.

 He lost one of his shoes among the cabbages, and
the other shoe amongst the potatoes.

 After losing them, he ran on four legs and
went faster, so that I think he might have got away
altogether if he had not unfortunately run into a
gooseberry net, and got caught by the large buttons

on his jacket. It was a blue jacket with brass buttons, quite new.
— BEATRIX POTTER
1866–1943

After a time she heard a little pattering of feet in the distance, and she hastily dried her eyes to see what was coming. It was the White Rabbit returning, splendidly dressed, with a pair of white kid gloves in one hand and a large fan in the other: he came trotting along in a great hurry, muttering to himself as he came, "Oh! the Duchess, the Duchess! Oh! won't she be savage if I've kept her waiting!"
— LEWIS CARROLL
1832–1898

When Mrs. Frederick C. Little's second son was born, everybody noticed that he was not much bigger than a mouse. The truth of the matter was, the baby looked very much like a mouse in every way. He was only about two inches high; and he had a mouse's sharp nose, a mouse's tail, a mouse's whiskers, and the pleasant, shy manner of a mouse. Before he was many days old he was not only looking like a mouse but acting like one, too—wearing a gray hat and carrying a small cane.
— E. B. WHITE
1899–1985

After several days . . . [Babar] comes to a town . . .

He hardly knows what to make of it because this is the first time that he has seen so many houses.

So many things are new to him! The broad streets! The automobiles and buses! However, he is especially interested in two gentlemen he notices on the street.

He says to himself: "Really they are very well dressed. I would like to have some fine clothes, too!" . . .

Without wasting any time Babar goes into a big store. . . .

Babar then buys himself: a shirt with a collar and tie, a suit of a becoming shade of green, then a handsome derby hat, and also shoes with spats.

Well satisfied with his purchases and feeling very elegant indeed, Babar now goes to the photographer to have his picture taken.

—JEAN DE BRUNHOFF
1899–1937

At this very moment, perhaps, Toad is busy arraying himself in those singularly hideous habiliments so dear to him, which transform him from a (comparatively) good-looking Toad into an Object which throws any decent-minded animal that comes across it into a violent fit. — KENNETH GRAHAME
1859–1932

fashion axioms

Vain trifles as they seem, clothes . . . change our view of the world and the world's view of us.

— VIRGINIA WOOLF
1882–1941

The clothes make the man.

— SAYING (Latin)

The Emperor's new clothes are the finest he has ever had. — HANS CHRISTIAN ANDERSEN
1805–1875

Carelessness in dressing is moral suicide.

— HONORÉ DE BALZAC
1799–1850

Dressing is the one art the unqualified must practise. — ELIZABETH BOWEN
1899–1973

Adornment is never anything except a reflection of the heart. — GABRIELLE ("COCO") CHANEL
1883–1971

Fashion comes from a dream.

— CHRISTIAN DIOR

1905–1957

Fashion must be the intoxicating release from the banality of the world. — DIANA VREELAND

1906–1989

afterword

ACRES: Dress *does* make a difference, David.
DAVID: 'Tis all in all, I think.
— RICHARD BRINSLEY SHERIDAN
1751–1816

credits